eggs

50 TRIED & TRUE RECIPES

Julia Rutland

Adventure Publications
Cambridge, Minnesota

Cover and book design by Jonathan Norberg
Edited by Emily Beaumont

Cover images: All images by Julia Rutland except bottom middle, **Syda Productions/shutterstock:** eggnog; bottom right, **Timolina/ shutterstock:** carbonera

All images copyrighted.

All images by Julia Rutland unless otherwise noted.

Used under license from Shutterstock.com:
Ambient Ideas: 21; **Tetiana Didenko:** 20; **gresei:** 9; **marcin jacha:** 18; **mahirart:** 16; **An Menshikova:** 10; **Mikhaylovskiy:** 6; **Zimeva Natalia:** 2-3; **Olexandr Panchenko:** 17; **Rawpixel.com:** 4-5; **sky-and-sun:** 19 bottom; **Stepanek Photography:** 19 middle

10 9 8 7 6 5 4 3 2 1

Eggs: 50 Tried & True Recipes
Copyright © 2022 by Julia Rutland
Published by Adventure Publications
An imprint of AdventureKEEN
310 Garfield Street South
Cambridge, Minnesota 55008
(800) 678-7006
www.adventurepublications.net
Printed in China
ISBN 978-1-64755-232-9 (pbk.); ISBN 978-1-64755-233-6 (ebook)

Acknowledgments

There may be one author, but many people are involved in creating a cookbook behind the pages. My deep thanks to Brett Ortler, Emily Beaumont, Liliane Opsomer, and Jonathan Norberg, and all the other behind-the-scenes staffers at AdventureKEEN.

Hugs and thanks to my personal support staff of family, friends, and neighbors, including Dit, Emily Bishop, Corinne, Nick, Greg, Tami, Cynthia, Ingrid, Joe, Eric, Katie, Vickie, Paige, Kristen, Rhonda, Sharon, Danielle, Dennis, Jackie, Susan, Randi, Denene, and Scott. I really appreciate your willingness to taste-test and the "you-go-girl" encouragement you've always given me. A special shout-out goes to Kathy Bui—I'm sure this will be one of many acknowledgments you receive in years to come.

My deepest gratitude must extend to our backyard flock of hens who provide us with countless delicious and beautiful eggs. And thanks to the two accidental roosters who guard the girls and offer hours of amusement!

eggs

50 TRIED & TRUE RECIPES

Table of Contents

Introduction

Eggs are simply marvelous. They are often ignored as a commonplace ingredient. For example, in cakes, their function as a leavener or a component that adds structure is hidden behind high-profile ingredients like chocolate or vanilla. But eggs can also be the glorious main attraction in recipes like deviled eggs or frittatas and omelets.

Although they are often associated with breakfast, eggs can star in every course, including appetizers, breads, soups, salads and salad dressings, main dishes, and sauces. And, of course, eggs shine in desserts where they serve as foundational ingredients or feature in puffy meringues or rich, silky sauces.

Creating a collection of egg recipes seems obvious—after all, there are so many ways to prepare them. The hard part is deciding what types of recipes and flavor combinations to develop. Here, I've opted for a middle ground. There are simple and basic recipes in this book, but I've also incorporated some interesting flavor combinations that are worth exploring. To be inclusive, I have also offered a few beverages and soups. In this book, my goal is to make sure that eggs are the primary ingredient or at least present in enough quantity for each entry to qualify as a true "egg" recipe. While there are many delicious types of eggs, including duck, goose, quail, and even ostrich, this book simply uses the ubiquitous and familiar large chicken eggs.

Eggs are economical, nutritious, widely available, delicious, and convenient. They can be used in simple to extravagant dishes and are appropriate for beginner cooks and accomplished chefs alike.

History

Eggs are one of the earliest human foods, and they have been consumed from prehistory to the present day. Over the millennia, eggs have provided an important source of nutrition as well as cultural symbolism. Until the mid-twentieth century, egg farms in the US were primarily family-based, backyard operations. Industrial advancement transformed small flocks into large commercial enterprises. Improved efficiency and sanitation led to increased egg production, but it also led to animal welfare concerns and adjustments to address them.

About 65% of commercially produced eggs are bought and used by home cooks. In the US, each person eats the equivalent of 286 eggs every year! (This doesn't mean entire eggs, of course, but eggs used as ingredients in other products.) About 4% of commercial eggs are used by the restaurant (food service) industry, about 3% are exported, and the remaining 28% are used by food manufacturers to make products we purchase at grocery stores. In all, more than 260 million cases of eggs are produced each year.

About Eggs

The terminology surrounding eggs can be a bit confusing. Here's a brief rundown of some of the words you'll encounter when buying eggs.

Egg Classifications and Marketing Terms

Commercial/nondisclosed: Eggs are laid by hens housed in small enclosures of about 8½ x 11 inches.

Free-range: Eggs are laid by hens with daytime access to outdoor areas.

Cage-free: Eggs are laid by hens with access to roam in a building or an open area that includes nesting space and perches. They should have unlimited access to food and water.

Enriched colony: Though they are still raised in cages, hens raised in enriched colonies have more space to walk, along with access to perches and nesting areas.

No added hormones: As it is illegal in the US to give hormones to poultry, this term is misleading and means little.

No added antibiotics: Chickens raised for egg production are rarely given antibiotics. This qualifier is more important for birds raised for meat. Antibiotics are given to reduce disease and increase growth.

Omega-3 eggs: These eggs are laid by hens fed a diet high in omega-3 fatty acids, for enhanced nutrition.

Local: These eggs are produced by hens located less than 400 miles away.

Vegetarian: These eggs are laid by hens that are exclusively fed vegetarian feed that contains no meat or fish by-products. Nonetheless, chickens are omnivores and get protein from grubs, worms, insects, etc. To remain strictly vegetarian, the hens are held indoors, but some companies use vegetarian feed and free-range techniques, allowing hens to graze on bugs and other things.

Organic: These eggs are laid by free-range or cage-free hens raised on organic feed that contains ingredients grown without pesticides, herbicides, or synthetic fertilizers. The hens are not given antibiotics or vaccines. The hens laying organic eggs do not undergo a forced molt. (Chickens naturally shed and replace feathers once a year, during which time they do not produce eggs. After a molt, the hen typically produces larger eggs.)

Pastured: These eggs are laid by hens that are allowed to freely roam and forage in fields. In addition to feed, hens may eat grass and other plant material, as well as insects.

Ideally, the best egg to eat is an organic one that is laid by pastured or free-range hens that have been raised in certified humane conditions.

Egg Colors

Although eggs in markets are generally only brown or white, hens lay eggs in a variety of colors, including blue and green. The color is determined by the breed of hen, but an egg's color doesn't affect its taste. Egg yolks vary from pale yellow to orange, with the color influenced by the hen's diet.

Other Egg Products

Dehydrated: Sometimes called powdered eggs, these are eggs that have been freeze-dried to remove all moisture. They come in several forms, including whole, just whites, or just yolks. They are lightweight and can be stored for extended times.

Meringue Powder: Bakers use meringue powder to stabilize frostings and icings. It contains more ingredients than just dried egg whites and may include cornstarch, sugar, citric acid, or other commercial stabilizers. It creates the ideal texture for easy-to-manage royal icing.

Pasteurized Eggs: These eggs have been heated to a temperature that will kill any bacteria but not so high as to actually cook the eggs.

Liquid Eggs: These eggs have been pasteurized, homogenized, and packaged in sealed boxes that are found in the refrigerated section of the grocery store. Because this product is pasteurized, it can be safely used in uncooked recipes like shakes, salad dressings, or when you're craving raw cookie dough that's safe to eat. *Measurement tip:* ¼ cup equals one large whole egg.

Liquid Egg Whites: Sold in cartons, this egg white product is pasteurized, which slightly changes its consistency compared to fresh egg whites separated from yolks. This means they may not be ideal in recipes using whipped egg whites, such as meringues. *Measurement tip:* 2 tablespoons are equivalent to 1 large egg white.

Egg Sizes

Eggs are commonly sold in stores in half-dozen or full-dozen cartons, and they are packaged by size/individual egg weight. Young, newly laying hens produce small eggs. Older hens produce larger eggs.

Size	Minimum Weight per Dozen	Minimum Weight per Egg
Jumbo	30 ounces	63 grams/2.2 ounces
Extra Large	27 ounces	56 grams/2.0 ounces
Large	24 ounces	50 grams/1.8 ounces
Medium	21 ounces	44 grams/1.6 ounces
Small	18 ounces	38 grams/1.0 ounce
Peewee	15 ounces	35 grams/1.25 ounces

Why does this matter? The most commonly sold egg size is large, and it is the default size for recipes in this and many other cookbooks. Knowing how large each grade of egg is in ounces is helpful, especially when using a different size in recipes or when using liquid eggs. For the most part, swapping large to medium eggs in recipes won't significantly affect the result, particularly in savory recipes such as scrambled and poached eggs, frittatas, etc. Other recipes, such as flan or homemade mayonnaise, require a specific ratio of egg to other ingredients and require a certain amount of egg for thickening power. In those instances, it would be wiser to err on the side of a bit more egg.

Approximate Substitutions

1 large egg = 3 tablespoons liquid eggs or 1 extra-large, 1 medium, or 1 small egg

2 large eggs = ¼ cup plus 2 tablespoons liquid eggs or 2 extra-large, 2 medium, or 3 small eggs

3 large eggs = ½ cup plus 2 tablespoons liquid eggs or 3 extra-large, 4 medium, or 4 small eggs

4 large eggs = ¾ cup plus 1 tablespoon liquid eggs or 3 extra-large, 5 medium, or 6 small eggs

1 large whole egg = 2 large egg whites

Nutrition

Eggs are a delicious and easy way to obtain complete dietary protein. (Foods containing all nine essential amino acids are considered "complete." The body cannot make these amino acids on its own). Two eggs contain about 11 grams of protein, with the yolk having slightly more protein than the white. Eggs are one of the few foods that naturally contain vitamin D. They contain all vitamins except vitamin C, and eating two eggs per day satisfies up to 30% of vitamin requirements. Egg yolks contain the brain-boosting nutrient choline, making cooked eggs an excellent food during pregnancy and childhood. Other nutrients, lutein and zeaxanthin, help maintain good vision.

The color of the egg doesn't affect any type of nutrition, so all colors—white, brown, green, blue—contain the same nutrients. Nutrients in each egg depend on a hen's diet, and high-quality feed results in optimal amounts of nutrients in eggs. Chickens fed with ingredients including flaxseed or fish oil produce eggs with increased Omega-3 fatty acids.

Egg Functions

Besides nutrition and flavor, eggs play a variety of important roles in recipes.

Aeration: The viscous nature of eggs helps provide structure and enables air to be incorporated into a batter. Beaten eggs lighten and contribute volume to many types of baked goods. Egg whites provide the aeration and structure needed to create fluffy meringues.

Binding: The protein in eggs can help bind ingredients together. This is especially useful when combining proteins with other ingredients, such as when making crab cakes, sausage patties, salmon cakes, and surimi (faux crab). Egg products also help breadcrumbs, panko, and other coatings adhere to food items.

Clarify: Egg whites have traditionally been used to clarify cloudy stocks, broths, or soups like consommé. To do so, beat 2 egg whites until soft peaks form, and then stir into the simmering broth. As the egg "raft" forms, it collects bits and pieces in the soup as it coagulates. Remove the egg raft and strain the broth through cheesecloth.

Coagulate or thicken: Eggs help liquids thicken by forming a mesh that creates a gel or semisolid state. Examples include cooked custards and cream sauces like Crème Anglaise. Further cooking curdles the eggs, but that is encouraged when making scrambled eggs.

Coating: Egg yolks, whites, and whole eggs are often brushed on the outside of baked goods (such as loaves of bread, rolls, and cookies) to provide a glossy finish and even color, and to seal in moisture.

Color: The protein in eggs provides a rich brown color as it cooks, while the yolks give cookies and cakes their sunny hue. To get a pure-white vanilla cake, cooks only use egg whites in the batter.

Emulsifier: Emulsions are combinations of ingredients that don't normally bind together (i.e., oil and water). They require an emulsifier (i.e., egg yolks) that allows the mixture to smoothly blend together. Lecithin is the component in egg yolks that serves as a natural emulsifier. Mayonnaise and hollandaise are considered emulsified sauces.

Leavening: Egg whites trap air that expands with heat during baking, allowing foods to be light and fluffy.

Storing Eggs

Keep eggs in an appropriate container on a refrigerator shelf and away from strong-smelling foods. Washed eggshells are porous and will absorb odors.

Place eggs large-end-up in the carton to help keep the yolks centered.

Store hard-boiled eggs in their shells up to 1 week. If shells are removed, place in an airtight container so they don't absorb odors.

Eggs can be frozen, but not in their shell. Beat egg whites and yolks together and freeze for up to 1 year. Egg whites can also be frozen by themselves. Egg yolks become gelatinous, so combine ⅛ teaspoon salt or 1½ teaspoons granulated sugar with 4 egg yolks. The whites of hard-boiled eggs will become watery if frozen, so freezing them is not recommended.

Egg Safety

At the market, check cartons for cracked or broken shells, and only purchase clean, intact eggs that have been consistently refrigerated at 40° or below.

Sell-by or expiration dates are printed on the outside of egg cartons, but the eggs are safe to eat for an additional 2 to 3 weeks. There is another three-digit number printed that corresponds to the date the eggs were packed in the carton. January 1 is 001, and this numbering pattern continues the rest of the year until 365, or December 31.

Room Temperature vs. Refrigeration

Eggs sold in US markets must remain refrigerated. Before packaging, the eggs are washed and sanitized to remove any surface debris and bacteria such as salmonella. This washing removes the outer coating on the egg, called the "bloom." Bloom is a thin coating that blocks the naturally occurring pores on the eggshell, preventing water loss and keeping bacteria from entering the inside of the shell. The bloom serves as a natural protective coating that allows eggs to be safe at room temperature for a few weeks. Eggs sold in Europe are not washed; therefore, they can be sold and stored at room temperature.

A Note About Raw or Undercooked Eggs

Some recipes, such as Caesar salad dressing, mayonnaise, or mousses, call for undercooked or raw eggs. For maximum safety, use pasteurized eggs when making such dishes. Casseroles, quiches, sauces, and other heated dishes with eggs as ingredients should be cooked to 160°. If reheated, cook to 165°.

Cross contamination occurs when bacteria transfers from raw foods such as chicken (and less commonly eggs) to hands or kitchen tools like cutting boards, knives, whisks, etc. To reduce the risk, wash hands after touching raw food. Wash all kitchen items before starting on a new task.

Cooking with Eggs

When beaten, egg whites at room temperature will produce more volume than fresh-from-the-fridge eggs. However, chilled eggs separate easier, so divide yolks from whites right after removing from the refrigerator, but allow the whites to stand at room temperature for about 30 minutes. Chilled eggs may also harden butter in cake batters, making it appear lumpy or curdled, so let eggs come to room temperature before adding them.

Crack eggs on a flat surface, rather than the side of a pan or bowl. Cracking on a thin edge pushes shell into the egg, possibly piercing the yolk and making separating them impossible.

Separated whites must not contain any yolk. The fat from the yolk prevents egg whites from whipping up light and airy. Make sure the bowl is clean and free from butter, oil, or any type of grease or fat.

To determine if a whole egg is raw or cooked, spin it on a flat surface. Hard-boiled eggs spin quickly. Raw eggs wobble erratically.

Basic Tips for Cooking with Eggs

Hard-boiled Eggs

Hard-boiled eggs, also known as hard-cooked eggs, are a misnomer. They shouldn't be cooked with a hard boil. In fact, the green ring that can occur around the yolk is a reaction between the iron in the yolk and sulfur in the egg white; this only occurs when the eggs are overcooked or cooked in very

high heat. Fresh eggs are difficult to peel because the white sticks to the membrane on the inside of the shell. As the egg ages, the white shrinks. Store eggs in the refrigerator 10 days to 2 weeks before cooking for easier peeling.

STOVE TOP: Place eggs in a saucepan large enough to hold them in a single layer. Add cold water to cover eggs by 1 inch. Bring just to a boil over high heat (do not allow to continue to boil). Remove from heat and cover with a lid. Let stand 12 minutes. Drain immediately and plunge in ice water for 5 minutes to stop the cooking process; drain again. Refrigerate immediately or, for easier peeling, remove the shells right after cooling in ice water.

INSTANT POT: Allow eggs to come to room temperature because chilled eggs may crack as they cook quickly. Place eggs pointed side down (for centered yolks) on an egg rack. (Two-tiered racks can hold twice as many eggs.) Don't pack them tightly together, and make sure there is space around each egg for steam. Add 1 to 1½ cups water to the bottom of the pot. Close and lock lid. Cook at high pressure for 5 minutes. Allow the pot to naturally release pressure for 5 minutes, then carefully move the valve to quickly release the remaining pressure. Plunge eggs into ice water for 5 minutes to stop the cooking process, and drain.

Scrambled

Scrambled eggs are simple to prepare, easy to serve to crowds, and take a multitude of seasonings and toppings. Many recipes call for milk, half-and-half, cream, or water, but this is mostly a matter of personal opinion. Straight beaten eggs work just fine and have a less-diluted egg flavor. Milk or water advocates claim that additional liquid may help keep the eggs from cooking too quickly. Water creates fluffier eggs, while the fat in the dairy additions creates creamier, firmer eggs. For each egg, use 1 to 2 teaspoons water, milk, half-and-half, or cream. Don't overcook or the eggs will form hard curds and leak moisture. Remove pan from heat after eggs are about 80% to 90% done; the residual heat will continue to cook the eggs.

STOVETOP: Crack 4 eggs into a bowl and beat thoroughly until whites and yolks are well blended. Add desired amount of salt and pepper. Melt enough unsalted or salted butter (about 1 to 1 ½ tablespoons) in a nonstick skillet over medium heat to coat the bottom of the pan when swirled. When butter foams, reduce heat to medium-low. Add eggs and cook, without stirring, until the edges around the pan begin to solidify. Slowly push the eggs from one side of the pan to another, folding the eggs over to create large curds. Remove from heat when cooked but still shiny on top, and allow residual heat to continue cooking the eggs. Sprinkle with cheese or herbs, if desired.

Omelet

Omelets are very similar to scrambled eggs but with a different cooking technique. Instead of continually scraping the spatula through the eggs to create fluffy curds, run the spatula from one edge to the center, allowing the uncooked liquid eggs to flow underneath. Repeat along the edge of the pan until there is no liquid left. Loosen any sticking areas of the omelet and flip over to gently cook the other side. Add any fillings in the center and fold over the edges to cover the fillings. You can fold over two sides to create a roll, or just one side to resemble a taco. Transfer to a plate, seam side down if rolled, and sprinkle with additional herbs and seasonings, if desired. Omelets should just be cooked to a firm texture and not have any dark-brown coloring. Have all the filling ingredients chopped and cooked ahead, if necessary. Some people may prefer to have any vegetables like onions, mushrooms, or peppers sautéed before using as a filling.

Fried

A fried egg is exactly that: A whole egg fried in butter or oil. Heat a tablespoon of salted or unsalted butter in a nonstick skillet over medium heat. When butter foams, reduce heat to medium-low. Crack 1 or 2 eggs into a ramekin before slipping into the pan for best results. Add eggs to pan and let cook until almost all of the whites are set. Flip each egg gently with a flat silicone spatula. Cook for 15 to 30 seconds or until whites are set and yolks are cooked to the desired degree of doneness.

FRIED EGG TERMINOLOGY

Over easy: The egg is flipped over in the skillet and the yolk is still runny.

Over medium: The egg is flipped over and the yolk is only slightly runny.

Over well: The egg is flipped over and the yolk is firm.

"Sunny side up" means the egg is fried and not flipped over. The trick to perfect sunny-side-up eggs with runny yolks is getting the whites to cook before the yolks firm up. After placing eggs in the skillet, cover with a lid and allow the steam to cook the whites. Add a few teaspoons of water before covering to enhance the steam.

Poached

Poached eggs are whole eggs cooked in gently simmering water until the whites are completely cooked but the yolks remain liquid. Poached eggs are typically used in Eggs Benedict recipes (page 49). Start with fresh eggs because they have plenty of thick whites and the yolks are less likely to break (plus they maintain a lovely oval shape). Pour water into a deep skillet or saucepan to a depth of at least 2 inches, and add 1 to 2 teaspoons vinegar. The water needs to be deep enough so it covers the entire egg and prevents the egg from settling directly on the bottom of the pan. The vinegar helps firm up the protein-rich egg white, keeping it from spreading too much in the water, but it is not required. Cook over medium-high heat until water begins to boil. Reduce heat to maintain a gentle simmer.

Crack eggs into ramekins. This helps keep the yolks intact; if one does break, you can save it for another use. Tip the ramekins into the water and allow the eggs to slide out. You can cook more than one egg at a time, but make sure they don't touch and there is enough space for the slotted spoon to scoop them out of the water. Cook for 3 minutes or up to 5 minutes if you want firm yolks. Remove carefully with a slotted spoon.

beverages, breads, and breakfast

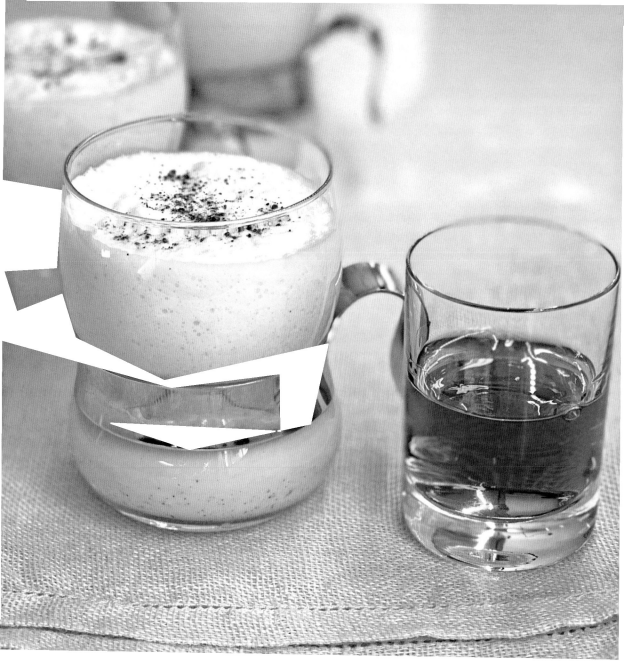

Eggnog

This version of the holiday drink includes beaten egg whites to lighten up the texture. You can skip this ingredient for a richer drink. For an adult version, add a shot of bourbon, whiskey, or rum to the glass before pouring in the eggnog.

makes 8 cups

INGREDIENTS
2 cups whole milk
2 cups heavy whipping cream
½ cup granulated sugar
¼ teaspoon ground nutmeg
6 large eggs
2 teaspoons vanilla extract

GARNISH
Ground nutmeg

Combine milk, cream, sugar, and nutmeg in a medium saucepan over medium-high heat. Cook, stirring frequently, until hot but not boiling.

Separate egg yolks from egg whites. Cover and chill egg whites until ready to serve. Whisk egg yolks in a medium bowl. Drizzle about ⅓ cup hot milk mixture into yolks; whisk and repeat with another ⅓ cup hot milk mixture. Pour yolk mixture into remaining hot milk mixture in pan; whisk to combine.

Cook, stirring constantly, until mixture reaches 160°. Remove from heat and stir in vanilla.

Let stand until room temperature; cover and chill several hours or overnight.

Before serving, beat egg whites until soft peaks form and fold into chilled eggnog. Garnish, if desired.

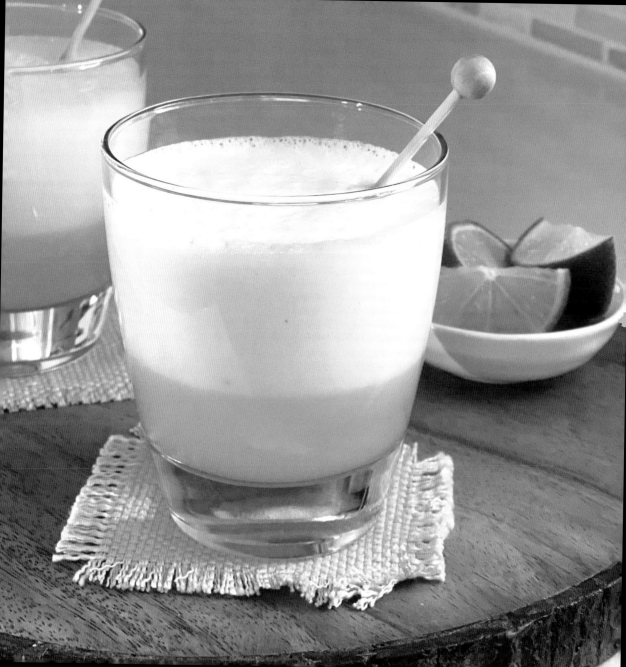

Blended Pisco Sour

Every summer when my dear friend Angie Williams comes back from Chile to visit,
we all get to enjoy her Pisco Sour cocktails. Pisco is a brandy-based spirit popular in Peru and Chile
that I haven't been able to find near me. Its herbal, musky flavor reminds me of tequila;
because the ingredients are similar to those in a margarita, tequila makes a fine substitute.
Angie makes hers frozen in a blender—refreshing in summer and easy to scale up—
and occasionally puts slices of spicy chili peppers in the bottom of each glass.
For a stronger version (because the crushed ice dilutes), place ingredients
in an ice-filled cocktail shaker; shake and strain into glasses.

makes 2 servings

INGREDIENTS

4 ounces (½ cup) pisco, tequila,
 rum, or vodka
¼ teaspoon lime zest (optional)
2 ounces (¼ cup) fresh lime juice
2 ounces (¼ cup) Simple Syrup
 (recipe at right)
1 cup crushed ice
1 egg white
Bitters

Combine pisco, zest, juice, Simple Syrup, and ice in a blender. Blend for 30 seconds or until smooth. Add egg white and blend for 5 to 10 seconds or until very frothy.

Pour into two glasses. Top each with a few drops of bitters.

Simple Syrup: Combine **1 cup granulated sugar** and **1 cup water** in a small saucepan. Cook, stirring occasionally, until sugar dissolves. Cool, and store in the refrigerator up to 1 week. For added flavor, Angie adds an orange rind to her syrup mixture. Makes 1½ cups.

Brioche

The bubble top on each loaf is made from balls of dough placed side by side,
a little offset, that appear interlocked after rising in the pan.

makes 2 loaves

INGREDIENTS

½ cup whole milk
⅓ cup granulated sugar, divided
1 (¾-ounce) package active
 dry yeast
2 cups all-purpose flour
2 cups bread or all-purpose flour
2 teaspoons salt
6 large eggs
12 tablespoons (1½ sticks)
 unsalted butter, softened
1 egg yolk
1 tablespoon water

Heat milk in a small saucepan over medium-low heat until warm (105° to 110°). Combine milk, 2 tablespoons sugar, and yeast in bowl of a stand-up mixer fitted with a dough hook. Let stand 5 minutes.

Combine flours, remaining sugar, and salt in a medium-size bowl. Add 6 eggs to milk mixture, stirring until well blended. Gradually add flour mixture to milk mixture, kneading slowly with dough hook until flour is incorporated. Increase speed to medium and knead with dough hook for 5 minutes.

Add butter, 1 or 2 tablespoons at a time, blending after each addition. Stop and scrape down sides of bowl and dough hook, as needed. Knead dough at medium speed for 5 to 7 minutes or until dough is smooth, shiny, and slightly sticky.

Transfer dough to a greased bowl and let rise for 1½ hours or until doubled in bulk. Cover with plastic wrap and refrigerate for 12 to 24 hours.

Turn dough out onto a floured surface; divide into 12 pieces and roll into balls. Place 6 balls in an alternating pattern in each of 2 loaf pans. Cover pans and let rise 1½ to 2 hours.

Preheat oven to 350°. Combine egg yolk and 1 tablespoon water. Brush over tops of loaves.

Bake for 35 to 40 minutes. Cool in pans for 5 minutes; turn out onto a wire rack to cool completely.

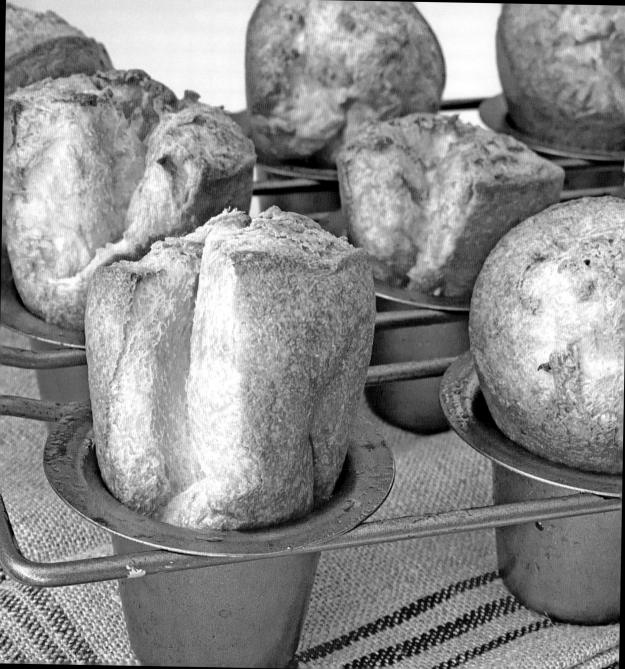

Popovers

Also known as Yorkshire puddings, these rolls are often served alongside roast beef
with the rendered fat that greases the pan, adding a lot of rich flavor.
Special popover pans have deep and narrow cups that make the tallest rolls.
You can use a muffin pan, but make sure the edges around the cups are greased,
too, or the batter will stick as it mushrooms over.

makes 1 dozen

INGREDIENTS

4 large eggs
1½ cups milk
1½ cups all-purpose flour
½ teaspoon salt
¼ cup melted clarified butter
or oil

Combine eggs and milk in a medium bowl, whisking until
well blended. Whisk in flour and salt. Let batter stand for at
least 30 minutes or until mixture is at room temperature.

Move oven rack to just above center. Preheat oven to 450°.

Place a 12-cup popover or muffin pan in the oven for 5 minutes.

Carefully remove pan from oven and brush melted butter
evenly in center and along sides of each cup. Stir batter, if
separated, and pour evenly among preheated cups (about
¼ cup each).

Bake for 10 minutes. Reduce oven temperature to 325°
and bake for 20 minutes or until golden brown and puffed.
Serve immediately.

Herbed Cheese Puffs

These delicious treats taste best warm and are sure to be devoured within a few minutes after leaving the oven. Serve them on their own, with salads, or with soups like tomato or vegetable.

makes about 3 dozen

INGREDIENTS

1½ cups water
12 tablespoons (1½ sticks)
 unsalted or salted butter
½ teaspoon salt
½ teaspoon coarsely ground
 black pepper
1½ cups all-purpose flour
7 large eggs
1 (8-ounce) package cheddar
 cheese, shredded
1 tablespoon minced fresh chives
1 tablespoon minced
 fresh parsley
1 tablespoon minced
 fresh rosemary

Preheat oven to 375°. Line 2 sheet pans with nonstick aluminum foil or parchment paper (or bake in batches).

Combine 1½ cups water, butter, salt, and pepper in a saucepan over medium-high heat and bring to a boil. Add flour and cook 3 minutes, stirring constantly, until dough comes away from sides of pan (there will be a light film on bottom of pan).

Transfer flour mixture to a mixing bowl. Beat on low speed for 2 to 3 minutes to cool. Beat in eggs, 1 at a time, stopping to scrape down sides of bowl. Stir in cheese, chives, parsley, and rosemary.

Spoon dough, using tablespoons to form each ball; place 1½ to 2 inches apart on prepared pans. Bake for 30 to 35 minutes or until golden brown.

Remove from oven and pierce sides of each puff with the tip of a knife to release steam. Serve warm.

Note: Puffs may be made ahead and frozen. Reheat at 325° for 10 minutes to crisp.

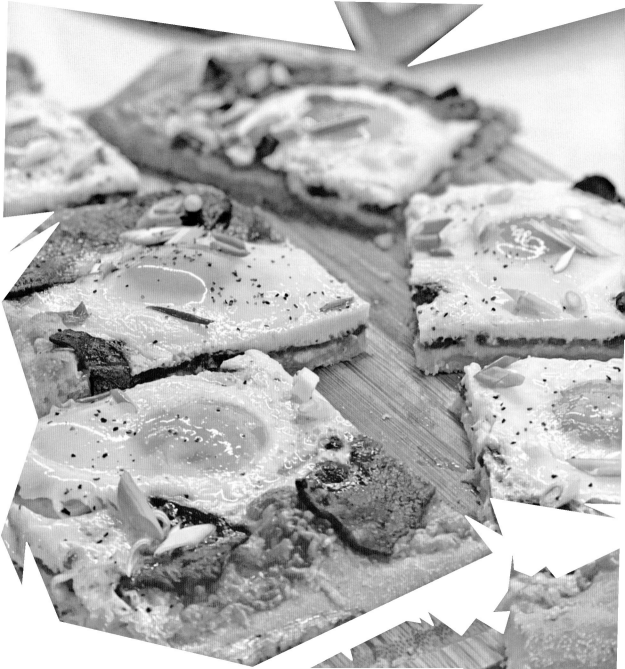

Breakfast Pizza

Keep your mornings as stress-free as possible and buy premade pizza dough so you won't
have to wake up early to prepare. Refrigerated dough balls bought in the deli section require rolling out,
while refrigerated dough in a can is quite tender and doesn't need any extra treatment. For a vegetarian version,
substitute 6 cooked and crumbled vegetarian breakfast sausage patties for the bacon and use
a strong-flavored cheese like cheddar instead of mozzarella and Parmesan.

makes 4 to 6 servings

INGREDIENTS

2 tablespoons semolina flour
　or fine cornmeal
1½ pounds (24 ounces)
　prepared pizza dough
2 tablespoons olive oil
1 garlic clove, minced
1½ cups (6 ounces) shredded
　mozzarella cheese
1 cup (4 ounces) grated
　Parmesan cheeese
6 slices crisp cooked bacon
6 small eggs or 4 large eggs
2 green onions, sliced
Cracked black pepper

Preheat oven to 450°. Grease a pizza pan and sprinkle with
flour or cornmeal.

Roll dough out onto a lightly floured surface, if necessary, un-
til ¼-inch thick; transfer to prepared pan. Combine olive oil
and garlic in a small bowl; brush over dough. Arrange cheeses
and bacon over dough.

Bake for 10 minutes. Carefully remove pizza from oven and
crack eggs evenly over top, taking care to keep yolks intact.
Return to oven, and bake 10 more minutes or until whites
are set and yolks are cooked to desired degree of doneness.
Sprinkle with green onions and pepper.

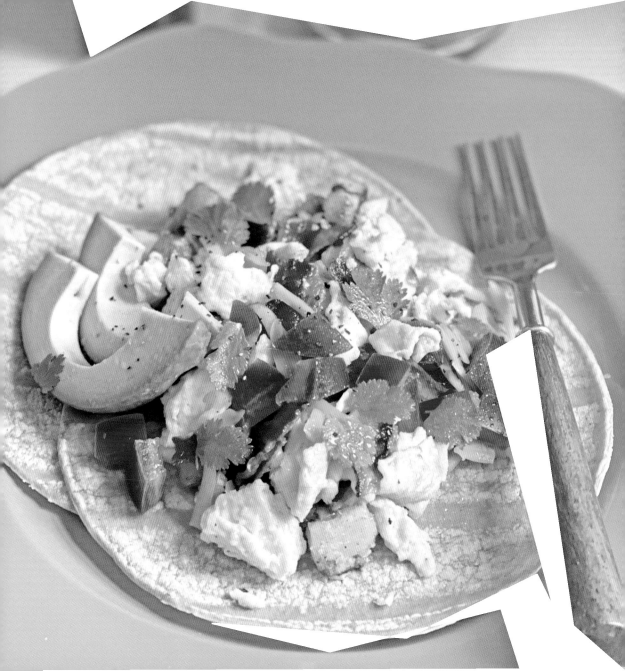

Breakfast Tacos

Consider serving this breakfast dish for dinner too.
You can stack two tortillas on top of each other per serving so their thickness
helps hold in the filling, or divide the egg mixture into two smaller tacos per person.

makes 4 servings

INGREDIENTS

4 medium-size red potatoes or 1 large russet potato, cubed
2 tablespoons extra-virgin olive oil, divided
1 teaspoon ground cumin
½ teaspoon salt, divided
4 to 8 (6-ounce) yellow corn or flour tortillas
8 large eggs, lightly beaten
4 slices bacon, cooked and crumbled
½ cup (2 ounces) shredded cheddar cheese
1 tomato, seeded and chopped
2 tablespoons chopped fresh cilantro
1 avocado, sliced

Cook potatoes in boiling salted water to cover for 5 minutes or until tender but not falling apart. Drain well.

Heat 1 tablespoon oil in a large nonstick skillet over medium heat. Add potatoes, cumin, and ¼ teaspoon salt. Cook, shaking pan and stirring occasionally, for 5 minutes or until golden brown. Transfer to a plate, and wipe skillet clean.

Wrap tortillas in a damp paper towel. Microwave on high for 1 minute or until hot. Keep covered until ready to serve.

Heat remaining 1 tablespoon oil in a large nonstick skillet over medium heat. Add eggs and remaining ¼ teaspoon salt. Cook, stirring occasionally, for 2 minutes or until halfway set. Stir in potatoes and bacon; cook 1 minute, stirring occasionally, until cooked through.

Serve eggs over tortillas. Sprinkle with cheese, tomato, and cilantro. Serve with sliced avocado.

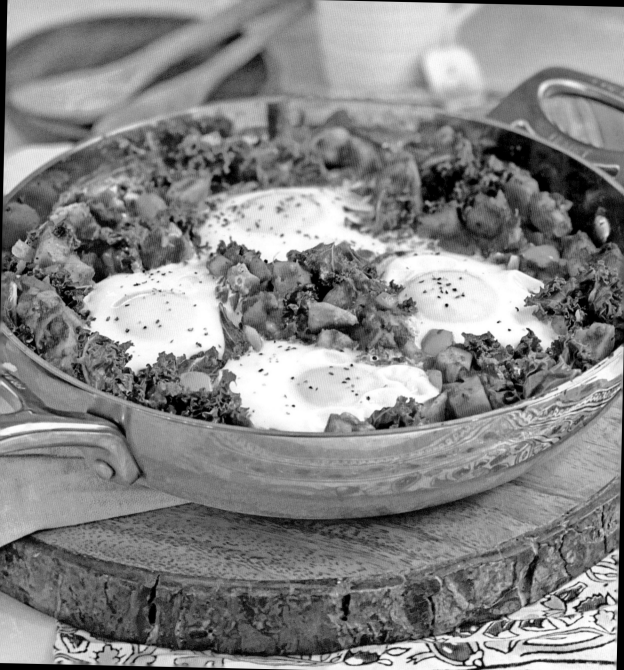

Sweet Potato, Kale, and Egg Hash

Use a glass lid when cooking the eggs so you can see how done they are without having to lift the lid. There's a soy-based chorizo sausage sold at Trader Joe's that's my go-to for high-flavor vegetarian protein, but you can find similar versions at other stores in the meatless section. There's no need to cook or brown the vegetarian sausage. If you want to use a traditional bulk sausage, brown it separately with ½ teaspoon ground cumin, ¼ teaspoon garlic powder, and ¼ teaspoon smoked paprika to give it the same flavor. Drain, if necessary.

makes 4 servings

INGREDIENTS

2 tablespoons extra-virgin olive oil
1 small red or yellow onion, chopped
1 red bell pepper, chopped
2 sweet potatoes, peeled and diced
1 teaspoon salt
3 cups coarsely chopped organic curly green or purple kale
8 ounces soy chorizo, crumbled or chopped
4 large eggs
¼ teaspoon coarsely ground black pepper

Heat oil in a large cast iron skillet over medium heat. Add onion, bell pepper, sweet potatoes, and salt. Cook, stirring frequently, for 5 minutes.

Add kale, stirring until well blended. Cover and cook for 10 minutes, stirring occasionally, until kale is wilted and tender. Add chorizo, stirring until well blended.

Create 4 shallow indentations in vegetable-sausage mixture. Crack 1 egg into each space. Cover and cook over low heat for 5 to 10 minutes or until egg whites are opaque and yolks are cooked to desired consistency. Sprinkle with pepper before serving.

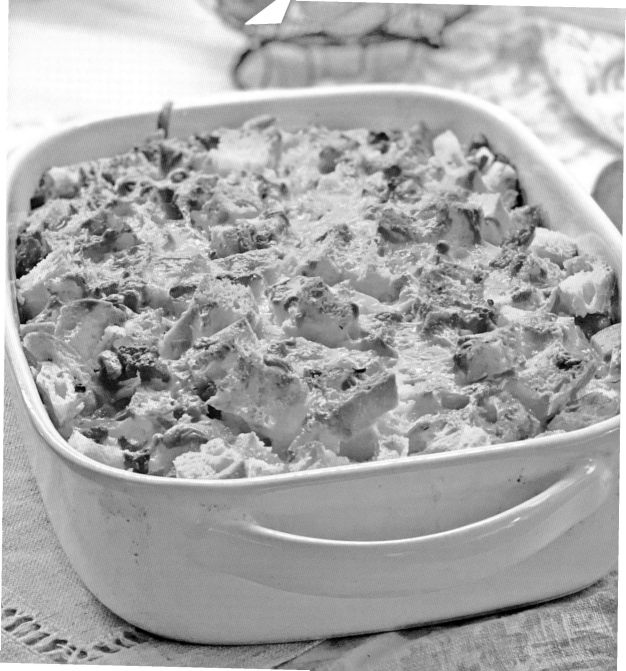

Cheese-and-Sausage Breakfast Bake

A good rosemary-olive oil or sourdough artisan loaf really boosts the flavor in this dish, additionally enhanced with a butcher-made or store-blended breakfast sausage bought in bulk by the pound. Stir in 1 tablespoon fresh chopped sage and swap out basic cheddar for smoked Gouda for a twist.

makes 8 servings

INGREDIENTS
1 pound bulk breakfast sausage
1 (15 or 16-ounce) loaf sour-
 dough bread, cubed
2 cups (8 ounces) shredded
 cheddar cheese
8 large eggs
4 cups half-and-half
1 teaspoon salt
1 teaspoon dry mustard
2 teaspoons Worcestershire sauce
1 teaspoon hot sauce
¼ cup (½ stick) unsalted or
 salted butter, melted

Butter a 13x9-inch baking dish.

Cook sausage in a large skillet over medium-high heat, stirring frequently, until meat is browned and no longer pink. Drain excess oil, if necessary.

Layer half of bread cubes in bottom of baking dish. Top with half of sausage and 1 cup cheese. Repeat layers once with remaining bread, sausage, and 1 cup cheese.

Whisk eggs in a large bowl. Whisk in half-and-half, salt, dry mustard, Worcestershire, and hot sauce. Pour egg mixture over bread mixture. Pour melted butter evenly over top. Cover with plastic wrap and refrigerate overnight.

Remove from refrigerator 30 minutes before baking. Preheat oven to 350°.

Uncover and bake 45 to 60 minutes or until golden brown, puffed, and firm in center.

Quick-and-Easy Egg Bites

My daughter Emily Bishop created this recipe, and she makes it frequently as her healthy go-to breakfast.
The bites will puff up like popovers and quickly deflate. This recipe is a basic cheese version.
Try adding a teaspoon of chopped rosemary or thyme to the egg mixture.
You can also add a tablespoon of chopped cooked bacon for more savory protein.

makes 2 to 3 servings (6 bites)

INGREDIENTS
Vegetable cooking spray
6 large eggs
¼ cup half-and-half
⅛ teaspoon salt
Pinch of coarsely ground
 black pepper
Pinch of cayenne pepper
Pinch of garlic powder
½ cup (2 ounces) shredded
 cheddar, mozzarella,
 or other cheese

Preheat oven to 350°. Lightly grease 6 cups of a muffin pan with cooking spray.

Whisk together eggs, half-and-half, salt, pepper, cayenne, and garlic powder in a medium-size bowl.

Pour egg mixture evenly into prepared muffin cups. Top evenly with cheese.

Bake 25 to 30 minutes or until puffed and done in center. Serve immediately.

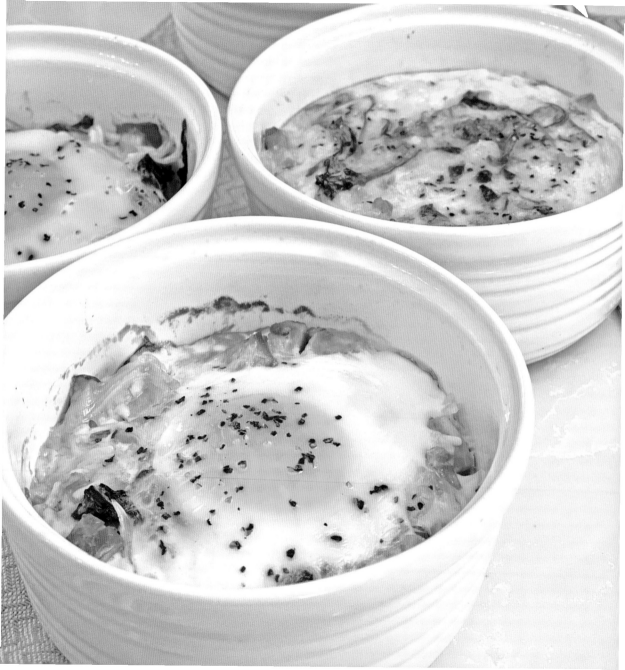

Baked Eggs with Spinach, Tomatoes, and Ham

There are so many ways to personalize these easy baked eggs. Skip the bacon or ham if you prefer a vegetarian version. Add chopped bell pepper with the onion (there's plenty of room) for extra vegetables. You can make these two ways—with scrambled eggs or by cracking whole eggs into the center, if you prefer runny yolks. I use sun-dried tomatoes because they don't water out, but if you like fresh tomatoes, feel free to substitute 1 small, chopped tomato, making sure to remove seeds and any liquid.

makes 4 servings

INGREDIENTS
Vegetable cooking spray
1 tablespoon extra-virgin
 olive oil
1 large shallot, minced, or ¼ cup
 minced onion
1 cup chopped Canadian bacon
 or lean ham
4 cups fresh baby spinach
 or arugula
2 tablespoons chopped
 oil-packed or dry
 sun-dried tomatoes
⅓ cup (3 ounces) shredded
 Parmesan cheese
4 large eggs
⅓ cup heavy cream
⅛ teaspoon coarsely ground
 black pepper

Preheat oven to 350°. Lightly grease 4 (8-ounce) ramekins with cooking spray.

Heat oil in a nonstick skillet over medium heat. Add shallot and cook, stirring frequently, until light golden brown. Stir in Canadian bacon and spinach. Cook 2 to 3 minutes, tossing with tongs, until spinach wilts. Stir in tomatoes.

Divide ham mixture evenly into prepared ramekins. Sprinkle evenly with cheese.

Combine eggs and cream in a small bowl. Pour evenly over ham mixture. (To use whole eggs, crack one egg into each ramekin and drizzle cream evenly over top.) Sprinkle with pepper.

Place ramekins on a sheet pan. Bake 15 to 20 minutes or until firm—or until egg whites are opaque and yolks are cooked to desired degree of doneness.

Cheesy Creamed Eggs

Cornstarch thickens the sauce while creating a silky texture.
Fresh grated or shredded cheese melts better and has a superior texture over packaged, pre-shredded cheese.
You can make lots of substitutions in the sauce. For a bold flavor, substitute pepper-Jack or goat cheese.

makes 6 servings

INGREDIENTS

6 hard-boiled eggs
1½ cups half-and-half or whole milk
1 tablespoon cornstarch
¼ teaspoon ground mustard
¼ teaspoon salt
⅛ teaspoon cayenne pepper
1 cup (4 ounces) shredded cheddar cheese
1 cup (4 ounces) shredded Gruyère, Swiss, or other cheese
6 split English muffins or whole wheat or sprouted grain bread, toasted
Paprika
Coarsely ground black pepper

Peel eggs and cut in half. Remove yolks and mash in a small bowl. Coarsely chop egg whites; set aside.

Whisk together half-and-half, cornstarch, mustard, salt, and cayenne in a saucepan over medium heat. Bring to a boil, reduce heat to simmer, and cook, stirring constantly, for 30 seconds or until mixture thickens.

Remove sauce from heat; add cheeses, stirring until cheeses melt. Add mashed egg yolks, stirring until well blended. Stir in chopped egg whites.

Serve creamed eggs over toasted muffins, and sprinkle with paprika and black pepper.

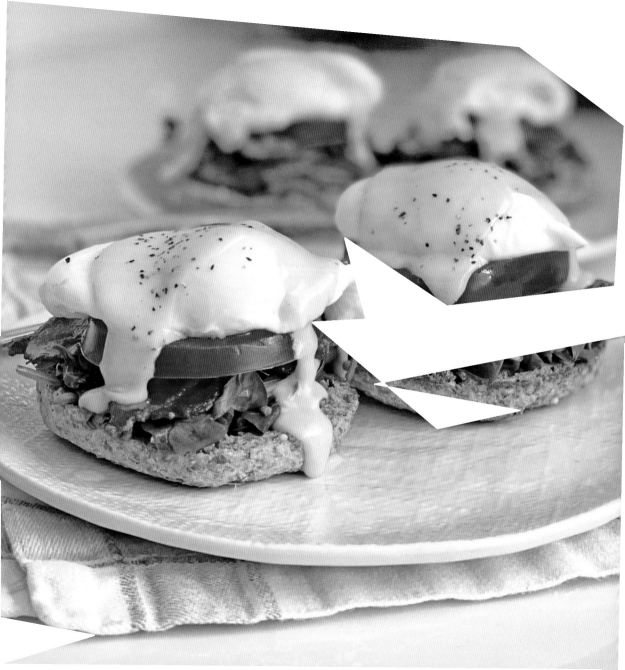

Bacon-Tomato Eggs Benedict

Hollandaise sauce can be troublesome if not cooked correctly.
Use a double boiler or a bowl placed over gently simmering water.
Don't try to make the sauce in a pan directly on the stove.

makes 4 servings

INGREDIENTS

8 slices lean bacon
2 tablespoons extra-virgin olive
 oil, divided
1 (5-ounce) container
 baby spinach
½ teaspoon salt
⅛ teaspoon coarsely ground
 black pepper
Hollandaise Sauce
 (recipe at right)
4 English muffins, split
8 tomato slices
1 teaspoon white vinegar
8 large eggs

Cook bacon in a skillet over medium heat until crispy. Remove to paper towels. Wipe skillet clean.

Heat 1 tablespoon olive oil in skillet over medium-high heat. Add spinach and cook, tossing with tongs, until wilted. Stir in salt and pepper. Cover and keep warm.

Prepare Hollandaise Sauce. Remove from heat; keep warm.

Toast muffins; top each muffin half evenly with spinach mixture, 1 slice of bacon (broken into 2 halves), and 1 tomato slice. Cover with aluminum foil to keep warm.

Fill a deep skillet with 2 inches of water. Bring to a simmer and stir in vinegar. Break 1 egg into a ramekin. Slide egg into simmering water. Repeat with remaining 7 eggs. Poach for 3 minutes and remove with a slotted spoon. Place eggs directly on top of tomato. Drizzle with Hollandaise Sauce.

Hollandaise Sauce: Whisk together **4 large egg yolks, 2½ tablespoons fresh lemon juice,** and **⅛ teaspoon cayenne pepper** in top of a double boiler. Place over barely simmering water. Add **½ cup (1 stick) butter, cut into pieces,** a few pieces at a time, to egg mixture. Cook over hot water, whisking constantly, until butter melts. Cook, whisking constantly, 5 minutes or until sauce thickens. Remove from double boiler; cover and keep warm. Makes 1 cup.

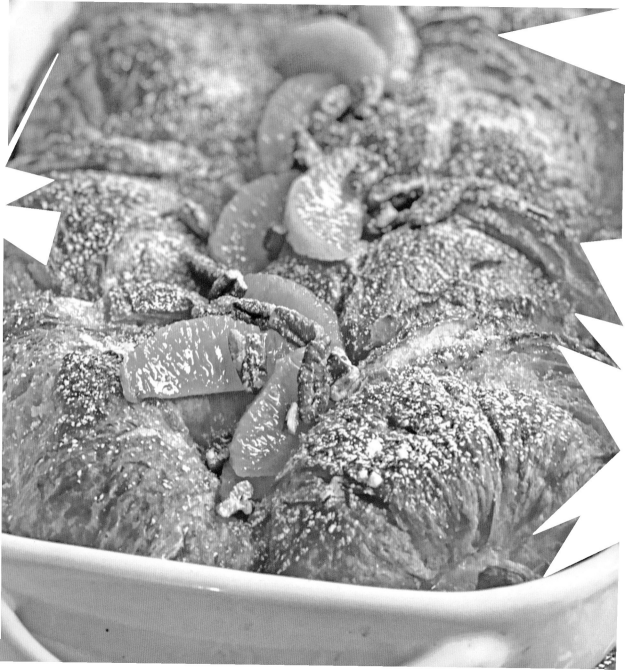

Orange-and-Cinnamon French Toast Casserole

Buy croissants in bulk at a warehouse store for the best deal, and then let them get stale.
They are naturally soft, so if using fresh, split and toast lightly or leave out for several hours to dry
before assembling. You can also use an Italian or sourdough bread loaf, but cut off any hard crusts.
You can take this to the next level by sprinkling a cup of chocolate chips over the bread before pouring
the egg mixture over the casserole. Save the orange you used for the brown sugar mixture.
Peel it and cut it into segments as a garnish.

makes 8 servings

INGREDIENTS
½ cup (1 stick) salted butter
1 cup firmly packed light
 brown sugar
1 to 2 teaspoons grated
 orange rind
1 cup chopped pecans (optional)
8 large croissants, split in half
 (about 15 ounces)
8 large eggs
2½ cups whole milk
1 teaspoon ground cinnamon
2 teaspoons vanilla extract

GARNISHES
Orange segments
Powdered sugar

Butter a 13x9-inch baking dish.

Melt butter in a small saucepan over medium heat. Add brown sugar; cook, stirring occasionally, for 2 minutes or until well blended. Stir in orange rind. Spread brown sugar mixture in bottom of baking dish. Sprinkle with pecans, if desired. Layer croissants on top.

Combine eggs, milk, cinnamon, and vanilla in a bowl; pour evenly over croissants. Press croissants down gently with a spoon to help absorb the custard mixture.

Cover and refrigerate 8 hours or overnight.

Remove casserole from refrigerator and uncover. Let stand 10 to 30 minutes.

Preheat oven to 375°. Bake for 25 to 30 minutes or until golden brown. Garnish, if desired.

Dutch Baby

Dutch Baby or Dutch Baby Pancake is a cross between a pancake, a crepe, and a popover.
The batter is thin like crepe batter, but it puffs a great deal along the edges.
To get that volume, make sure the pan is very hot when you pour in the batter.
Butter melts into the hot pan to reduce sticking, and I like to return it to the oven for a
minute or so to get that rich brown-butter flavor. Like all crepe or pancake batters,
let the batter sit for 20 to 30 minutes (or longer in the refrigerator) for best results.

makes 6 servings

INGREDIENTS
4 large eggs
1 cup whole milk
1 cup all-purpose flour
¼ cup granulated sugar
½ teaspoon salt
2 teaspoons vanilla extract
4 tablespoons unsalted or
 salted butter
1 pint raspberries, blackberries,
 or strawberries (or a mix of
 all three)
Powdered sugar
Sliced almonds
Maple syrup

Combine eggs, milk, flour, sugar, salt, and vanilla in a blender or food processor. Blend, scraping down sides, for several seconds or until the mixture is smooth and silky. Let batter rest 20 to 30 minutes.

Preheat oven to 425°. Place a 10- to 12-inch cast-iron or heavy oven-safe skillet in oven to preheat.

Carefully remove hot skillet and add butter. Tilt and swirl pan until butter melts and coats bottom and sides of skillet. Pour batter over butter.

Bake for 20 minutes or until puffed and golden brown.

Remove from oven (Dutch Baby will fall when it starts to cool). Top with fruit and sprinkle with powdered sugar and almonds. Serve with maple syrup.

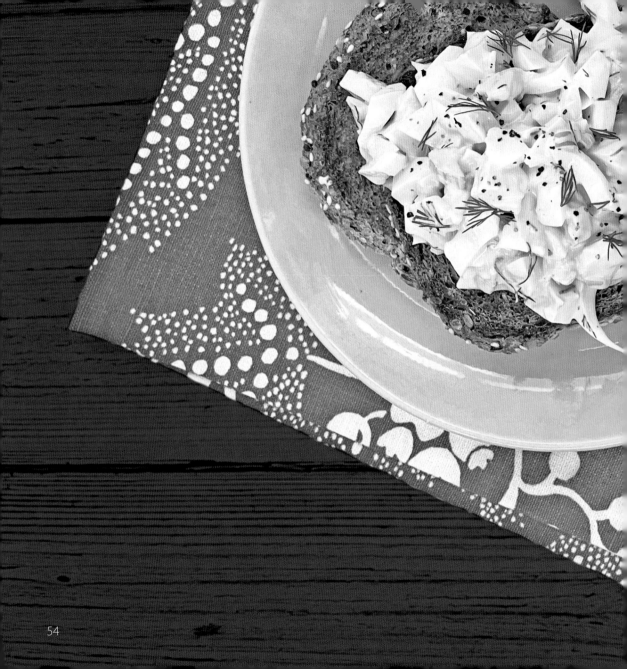

appetizers, soups, and salads

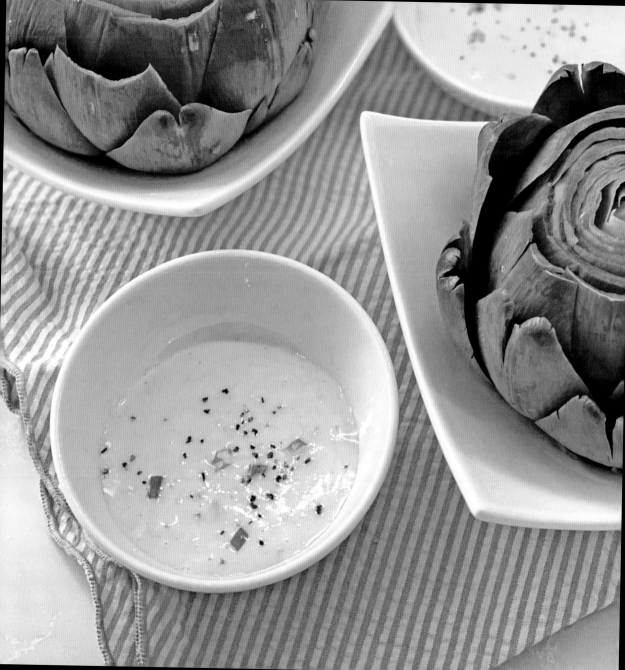

Lemon–Chive Aioli

Aioli is a variation of mayonnaise, featuring garlic and other flavors, that makes a tasty dipping sauce for artichokes and roasted or fried vegetables. You can also use it as a sandwich spread— it's really good on BLTs. Using a whisk might get tiring, so you can prepare the sauce in a small food processor or blender. I often put the ingredients in a small but deep bowl and use an immersion blender to quickly incorporate the oil.

makes 1 cup

INGREDIENTS
2 egg yolks, at room temperature
2 garlic cloves, minced
¾ teaspoon lemon zest
2 tablespoons fresh lemon juice
¾ teaspoon Dijon mustard
¾ teaspoon salt
⅛ teaspoon cayenne pepper
¾ cup extra-virgin olive oil
1 tablespoon chopped fresh chives
 or minced green onion

GARNISH
Coarsely ground black pepper

Whisk together egg yolks, garlic, zest, juice, mustard, salt, and cayenne in a medium bowl.

Gradually add oil, a few drops at a time, and then slowly drizzle it in a thin stream, whisking constantly, until the mixture thickens. Stir in chives. Garnish, if desired.

Caribbean Lime Aioli: Substitute **lime zest** and **lime juice** for lemon, **chopped fresh cilantro** for chives, and add **½ teaspoon ground cumin.**

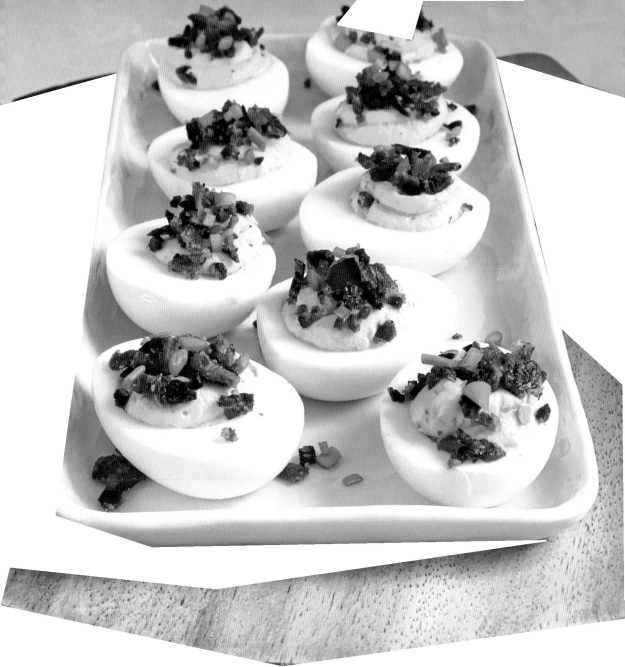

Bacon–Horseradish Deviled Eggs

Spicy prepared horseradish makes these boiled-egg appetizers deviled instead of simply stuffed.
You can add 1 tablespoon chopped pickle relish for a dash of crunch and sweetness.

makes 1 dozen

INGREDIENTS

6 hard-boiled eggs
¼ cup mayonnaise
1 tablespoon prepared horseradish
1 teaspoon prepared
 Dijon mustard
¼ teaspoon coarsely ground
 black pepper
2 strips bacon, cooked
 and crumbled
1 tablespoon chopped chives or
 green onion

Cut eggs in half. Remove yolks and transfer to a bowl. Mash yolks and stir in mayonnaise, horseradish, mustard, and pepper.

Stir yolk mixture until very smooth. Spoon or pipe yolk mixture into centers of egg whites. Sprinkle evenly with bacon and green onion.

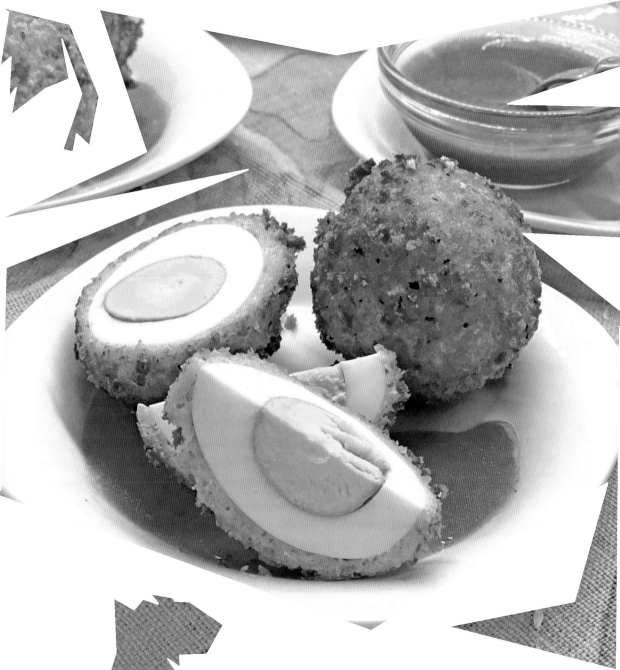

Fried Buffalo Eggs

Similar to Scotch eggs but without the meat, these snacks are fun and very filling.
Cut them into quarters to make an interesting topper for a salad.
Prepare eggs that are a little less cooked than usually desired.
The second cooking in the hot oil will cook the center even more.
The triple process of battering the eggs—flour, egg, panko—
is a hassle but needs be repeated so the entire surface of the egg is heavily coated.
Add more egg or panko to the bowl, if necessary.

makes 6 servings

INGREDIENTS

¼ cup all-purpose flour
2 large eggs, lightly beaten
¾ cup seasoned panko
6 soft- or hard-boiled eggs,
 peeled
Vegetable oil
Buffalo Sauce (recipe at right)

Place flour in a shallow bowl. Place beaten eggs in a separate shallow bowl. Place panko in a third shallow bowl.

Roll boiled eggs in flour and dip in beaten eggs, allowing excess to drip off. Roll in panko. Dip panko-coated boiled eggs again in beaten eggs and roll again in panko, making sure the surface is well and thickly coated.

Pour oil to at least 2 inches deep in a deep fryer or saucepan, and heat to 350°. Cook coated eggs, in batches, for 2 to 3 minutes, turning if necessary, until golden brown. Drain and serve with Buffalo Sauce.

Buffalo Sauce: Combine **¼ cup butter (melted)**, **¼ cup hot sauce**, **1 teaspoon apple cider or white vinegar**, **¼ teaspoon Worcestershire sauce**, and a **pinch of garlic powder** in a small bowl. (Recipe may be doubled and stored in the refrigerator. up to 1 week.) Makes ½ cup.

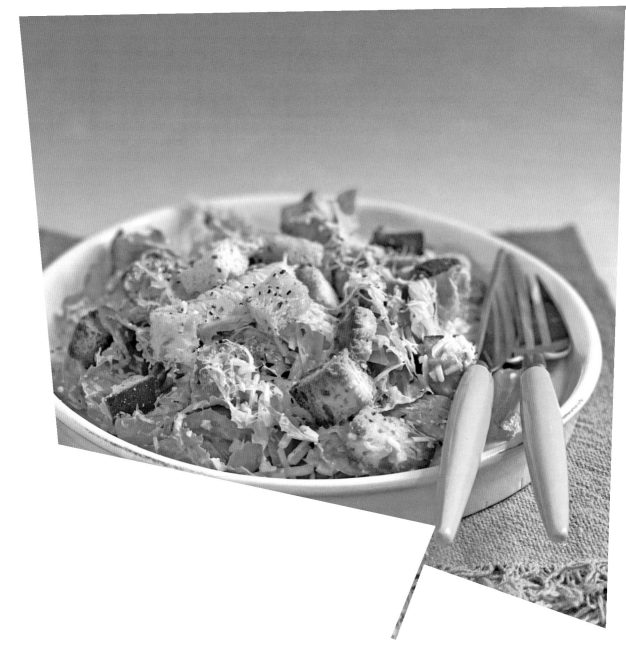

Caesar Salad

Traditional Caesar dressings contain eggs or egg yolks that help emulsify or bind the ingredients together. The egg also creates a thick texture that will cling to lettuce leaves. Look for pasteurized eggs, and use any leftover dressing by the next day. If you want to make ahead, prepare the dressing no earlier than the morning before for best results, as the flavor gets "eggy" if held too long.

makes 4 to 6 servings

INGREDIENTS

3 tablespoons salted or unsalted butter, melted
2 garlic cloves, finely minced and divided
½ teaspoon salt, divided
3 cups cubed French bread or Brioche bread (recipe on page 29)
2 large egg yolks, at room temperature
¼ teaspoon lemon zest
2 tablespoons fresh lemon juice
1 to 2 teaspoons Worcestershire sauce
½ teaspoon anchovy paste (optional)
½ cup extra-virgin olive oil
3 heads Romaine lettuce, washed and torn into pieces
⅓ cup (3 ounces) freshly grated Parmesan cheese
¼ teaspoon coarsely ground black pepper

Preheat oven to 375°. Line a sheet pan with aluminum foil.

Combine butter, half of garlic, and ¼ teaspoon salt in a large bowl. Add bread, tossing to coat. Spread in an even layer in prepared sheet pan.

Bake for 12 to 15 minutes or until golden brown. Let croutons cool to room temperature.

Combine yolks; zest; lemon juice; Worcestershire sauce; anchovy paste, if desired; remaining garlic; and remaining ¼ teaspoon salt in a blender or small food processor. Mix until well blended and smooth. With blender running, slowly drizzle in olive oil.

Place lettuce in a large bowl. Add dressing, tossing to coat. Add cheese, tossing to coat. Divide among serving bowls and sprinkle with black pepper and croutons.

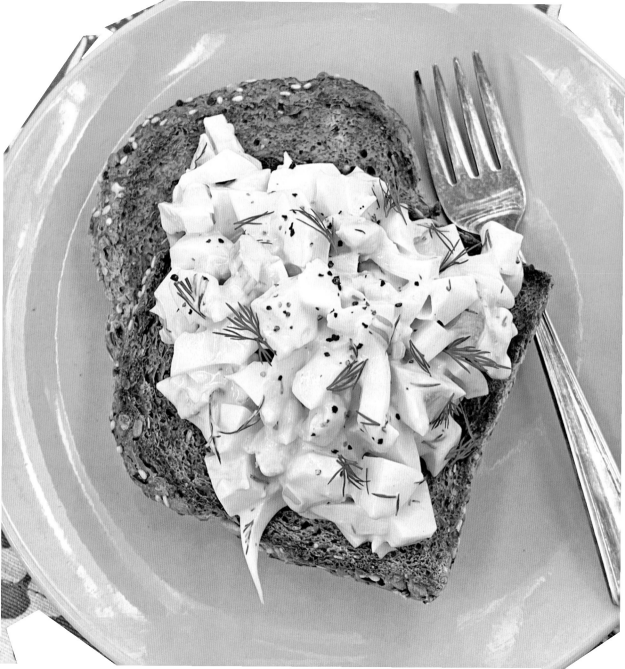

Dilled Egg Salad

Fresh dill adds a light herbal flavor to this simple egg salad. If you like it a bit tangier, stir in 2 tablespoons chopped dill pickle, along with a teaspoon or two of pickle juice to taste. The core of this recipe is the hard-boiled eggs. Overcooked egg yolks will give the salad a grayish-green cast and taste a little bitter. If you goofed and have dark-rimmed yolks, just reduce the amount of yolks. Egg whites are chopped, but you may find it easier to simply crumble the yolks into the salad mixture.

makes 3½ cups

INGREDIENTS

⅓ cup mayonnaise
2 tablespoons sour cream
1 teaspoon Dijon mustard
2 teaspoons fresh dill, minced
¼ teaspoon salt
2 small celery stalks,
 finely chopped
1 green onion, finely sliced
12 hard-boiled eggs
Coarsely ground black pepper
 to taste

Combine mayonnaise, sour cream, mustard, dill, and salt. Stir in celery and onion.

Cut eggs in half and chop whites and yolks separately. Stir into mayonnaise mixture. Sprinkle with pepper before serving.

Avgolemono with Chicken and Rice

This light soup is all about comfort—
perfect for a cozy meal or whenever someone is feeling a bit under the weather.
Bone-in chicken adds more flavor, but it's fine to use boneless if that's what's available.
Per weight, boneless chicken results in more meat, and there's plenty of broth to handle the extra.

makes 6 servings (about 11 cups)

INGREDIENTS
8 cups chicken broth
½ onion, cut into chunks
3 garlic cloves, chopped
1 teaspoon fresh thyme leaves
1 teaspoon salt
1 ½ pounds skinless chicken thighs or breasts
¾ cup long-grain rice
5 large eggs
⅓ cup lemon juice

GARNISH
Fresh parsley or dill, chopped

Combine broth, onion, garlic, thyme, and salt in a soup pot over medium heat. Bring to a boil; reduce heat to simmer. Add chicken. Cook for 20 minutes or until chicken is cooked through. Skim away any foam that appears on top.

Strain out chicken and vegetables, returning broth to soup pot. When chicken is cool enough to handle, shred meat and set aside.

Heat strained broth over medium heat; bring to a simmer. Add rice, and cook 20 minutes or until tender.

Whisk eggs and lemon juice until very foamy. Slowly drizzle about ½ cup hot broth into egg mixture, whisking constantly. Repeat; then whisk egg mixture back into the soup pot.

Cook soup over low heat, whisking constantly, for 3 to 4 minutes or until the texture is silky and thickened. Stir in reserved chicken. Ladle into bowls and sprinkle with parsley or dill.

Egg Drop Soup

If you are looking for a very easy and soothing soup, try this simple recipe.
There are not a lot of other ingredients, so broth is important.
Use homemade or the best quality you can buy at the market.
Because sodium varies, start with the lowest amount, and then taste.
This makes a great sick-day broth, but I omit the sesame oil and chives to sooth sensitive stomachs.

makes 4 cups

INGREDIENTS
3 cups chicken broth, divided
2 tablespoons cornstarch
2 teaspoons soy sauce
1 teaspoon dark sesame oil
½ teaspoon ground ginger
2 large eggs, lightly beaten
¼ to ½ teaspoon salt,
 or more to taste
2 tablespoons chopped
 fresh chives

Combine ½ cup broth and cornstarch in a small bowl; set aside.

Combine remaining 2½ cups broth, soy sauce, sesame oil, and ginger in a saucepan over medium heat. Cook for 5 minutes or until hot. Stir cornstarch mixture into broth mixture; cook for 2 minutes, stirring frequently, or until soup thickens.

Remove pan from heat. Stir soup slowly in a circle while drizzling in beaten eggs, creating long ribbons. Add salt, and sprinkle with chives.

Hot and Sour Soup

This flavorful soup uses tofu with an option for shrimp. If you prefer more protein,
you can add 1 very lightly packed cup of chicken breast or pork loin, cut into strips.
If these ingredients are raw, add them right after bringing the soup to a simmer,
and cook with (or instead of) shrimp. This version of the popular Chinese restaurant staple is
spicy enough, but you can serve it with extra hot sauce for those wanting maximum heat.
I usually make this in a big batch (reheat gently to enjoy the next day!).

makes 12 cups

INGREDIENTS

2 tablespoons peanut or canola oil
2 garlic cloves, minced
1 tablespoon grated fresh ginger
5 to 8 ounces shiitake or baby
 bella mushrooms, stems
 removed and thinly sliced
8 cups chicken or vegetable
 broth, divided
¼ cup soy sauce
⅓ cup seasoned rice vinegar
2 to 3 teaspoons chili paste or
 Sriracha sauce
1 teaspoon sesame oil
½ to 1 teaspoon coarsely ground
 black pepper
8 ounces raw peeled and
 deveined shrimp (optional)
1 (15-ounce) package extra-firm
 tofu, cubed
1 (4.9-ounce) can bamboo
 shoots, cut into slivers
¼ cup cornstarch
2 large eggs, lightly whisked
3 green onions, thinly sliced

Heat oil in a Dutch oven or soup pot over medium heat.
Add garlic and ginger; sauté 30 seconds or until fragrant.
Add mushrooms; sauté 1 minute. Stir in 7½ cups broth,
soy sauce, vinegar, chili paste, sesame oil, and pepper.

Bring to a boil; add shrimp, if desired, and cook 2 to 3 minutes
or until done. Stir in tofu and bamboo shoots.

Combine remaining ½ cup broth and cornstarch in a small
bowl, stirring until smooth. Stir cornstarch mixture into soup.
Simmer 1 to 2 minutes or until slightly thickened.

Remove from heat. Add eggs, stirring very slowly in one
direction, creating long ribbons of cooked eggs. Stir in green
onions. Season with additional chili paste and/or soy sauce,
if desired.

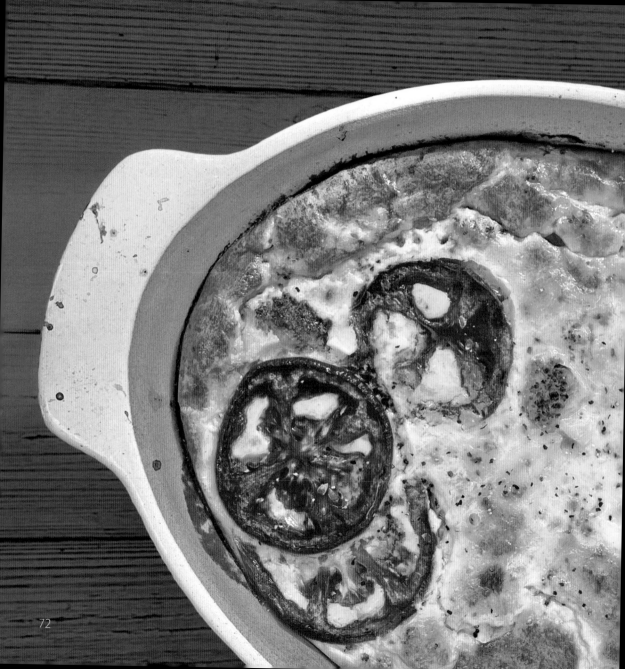

entrées and sides

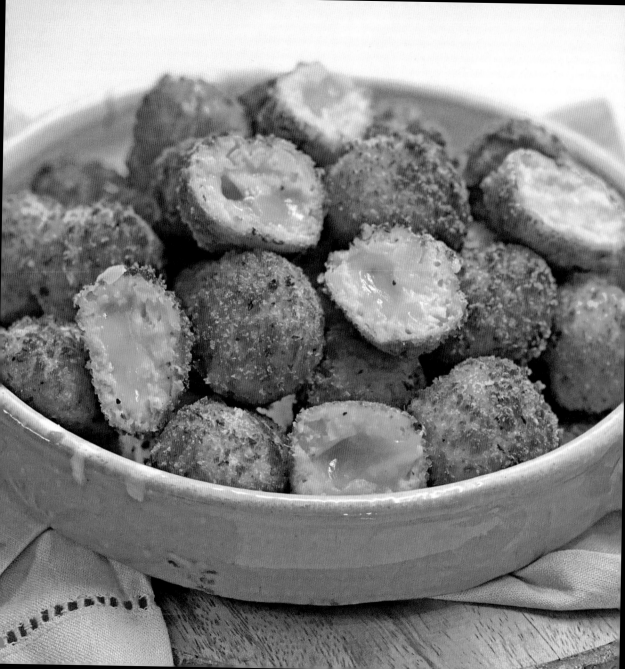

Cheesy Potato Croquettes

1½ pounds of potatoes makes about 3 cups mashed. For a shortcut, use leftover mashed potatoes.
The potato mixture should be tender, but chilling it in the refrigerator will firm it up, making it easy to roll into balls.
The croquettes should be chilled before frying, giving you time to prepare a side dish or appetizer.

makes 2 dozen

INGREDIENTS

1½ pounds Yukon gold
 potatoes, peeled and cubed
½ cup (2 ounces) freshly grated
 Parmesan cheese
¼ cup salted butter, softened
½ teaspoon salt
¼ teaspoon coarsely ground
 black pepper
4 large eggs, divided
2 ounces cheddar cheese, cut
 into 24 (¼-inch) cubes
½ cup all-purpose flour
2 cups seasoned
 panko breadcrumbs
Vegetable oil

Cook potatoes in boiling salted water for 10 minutes or until very tender. Drain and transfer to a bowl. Run potatoes through a food mill or mash with a fork or potato masher. Whisk in Parmesan, butter, salt, pepper, and 2 eggs.

Form potato mixture into 24 (1½-inch) balls. Place one cheese cube in center of each ball, pressing potato mixture around cheese to cover. Refrigerate until well chilled.

Place flour in a shallow bowl. Beat remaining 2 eggs in a second shallow bowl. Place panko in a third shallow bowl.

Roll chilled potato balls in flour. Roll in egg, letting excess drip off. Roll in panko.

Pour oil to a depth of 1 to 2 inches in a heavy skillet. Heat to 350° over medium-high heat. Fry potato croquettes, in batches, for 3 to 4 minutes, turning occasionally, until golden brown on all sides.

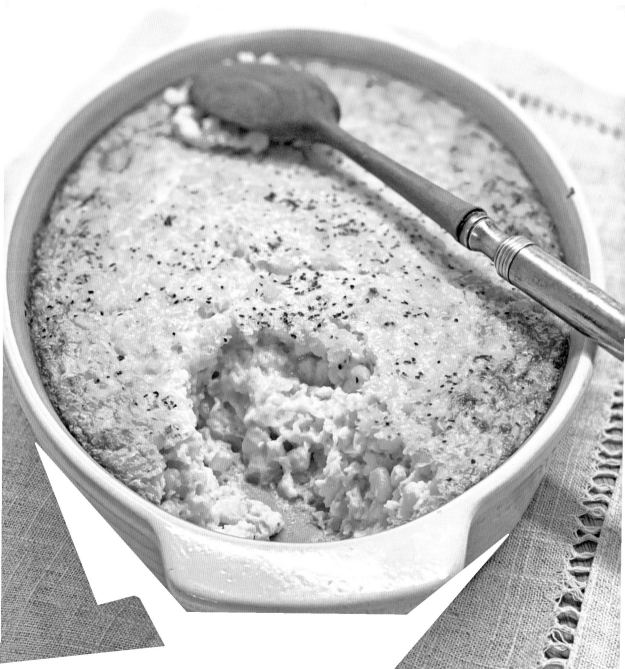

Sweet Corn Pudding

This simple side dish is not only delicious but very easy to put together if you keep frozen corn on hand. Processing half of the corn helps create a custard-like texture. Sprinkle ½ cup shredded cheddar cheese on top to make it richer.

makes 8 servings

INGREDIENTS

Vegetable cooking spray
5 large eggs
1½ cups half-and-half
¼ cup lightly packed light brown sugar or granulated sugar
¼ cup salted or unsalted butter, melted
2 tablespoons all-purpose flour
2 teaspoons baking powder
1 teaspoon salt
1 (19-ounce) or 2 (12-ounce) packages frozen corn, thawed and divided
¼ teaspoon coarsely ground black pepper

Preheat oven to 350°. Lightly grease an 11x7-inch or 2-quart baking dish with cooking spray.

Combine eggs, half-and-half, sugar, butter, flour, baking powder, salt, and half of corn in a food processor. Process 15 seconds or until well blended.

Stir in remaining corn kernels. Pour into prepared baking dish and sprinkle with pepper.

Bake for 45 to 60 minutes or until just set in the center.

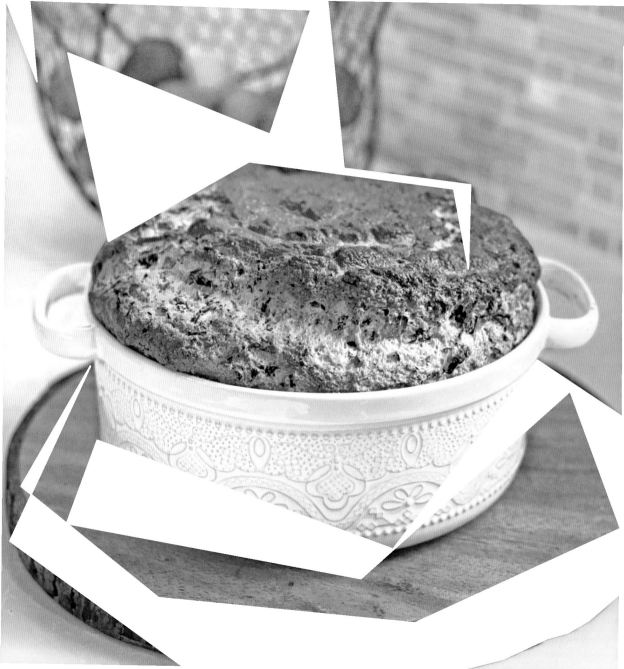

Spinach-and-Gruyère Soufflé

Soufflés have a reputation for being fussy and difficult to create—not so! Ignore the temptation to open the door to check on its progress—a sudden drop in temperature may cause it to collapse.

makes 4 to 6 servings

INGREDIENTS

2 tablespoons fine plain or seasoned breadcrumbs
3 tablespoons unsalted or salted butter
½ small onion, minced
3 tablespoons all-purpose flour
1 cup whole milk
¼ teaspoon salt
⅛ teaspoon coarsely ground black pepper
¼ teaspoon ground nutmeg
Pinch of cayenne pepper
½ cup (2 ounces) grated Gruyère or Swiss cheese
1 (10- to 12-ounce) package frozen chopped spinach, thawed and well drained
5 large egg yolks, at room temperature
6 large egg whites, at room temperature
¼ teaspoon cream of tartar

Preheat oven to 400°. Butter bottom and sides of an 8-cup or 2-quart soufflé dish. Sprinkle evenly with breadcrumbs.

Melt 3 tablespoons butter in a saucepan over medium heat. Add onion and cook, stirring frequently, for 3 minutes or until tender. Add flour and cook, stirring constantly, for 1 minute. Whisk in milk, salt, pepper, nutmeg, and cayenne. Cook, whisking constantly, for 1 to 2 minutes or until smooth and thick.

Remove from heat and stir in cheese, spinach, and egg yolks.

Combine egg whites and cream of tartar in a large bowl. Beat with a mixer at low speed for 1 minute. Increase speed to high and beat until stiff peaks form. Gently fold one-fourth of egg white mixture into cheese mixture to lighten. Gently fold remaining egg white mixture into cheese mixture.

Place soufflé in oven and reduce heat to 375°. Bake for 35 minutes or until puffed and golden brown. (Do not open oven door or soufflé may deflate.) Serve immediately.

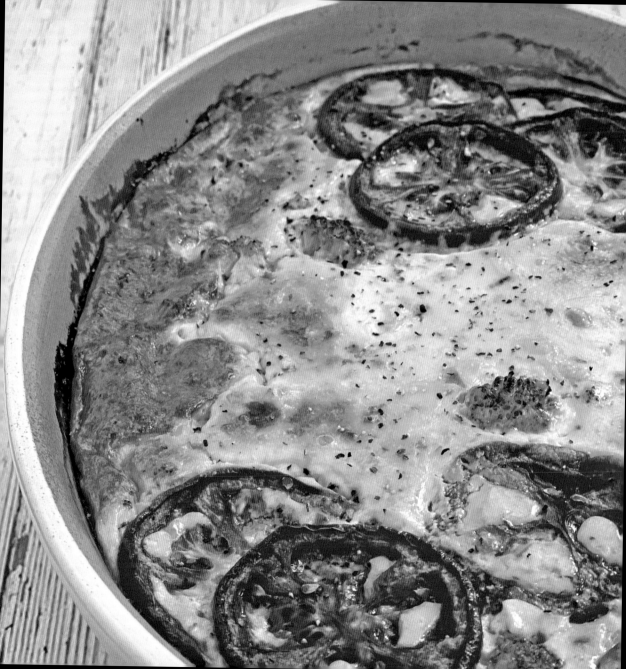

Broccoli Soufflé Casserole

This makes a great standby side or main dish meal because the ingredients can be kept for weeks in the refrigerator. It is light and tender like a quiche, and the flavor is divine— a great way to get hesitant kids to try broccoli. The texture will be a little different, but thawed and well-drained frozen spinach can be substituted for fresh.

makes 6 servings

INGREDIENTS

Vegetable cooking spray
1 (12-ounce) package frozen broccoli, thawed and drained
2 tablespoons unsalted or salted butter
½ onion, chopped
2 tablespoons all-purpose or gluten-free flour
½ teaspoon salt
⅛ teaspoon coarsely ground black pepper
1½ cups whole milk
1½ cups (6 ounces) shredded sharp cheddar cheese
½ cup sour cream
4 large eggs, lightly beaten
1 tomato, sliced and seeded (optional)

Preheat oven to 350°. Grease a 9x9-inch or 2-quart baking dish with cooking spray.

Cook broccoli according to package directions until crisp-tender. Coarsely chop any large stems. Place in an even layer in bottom of baking dish.

Melt butter in a large skillet over medium heat. Add onion and cook, stirring frequently, for 5 minutes or until tender. Stir in flour, salt, and pepper. Cook, stirring constantly, for 1 minute.

Whisk in milk. Bring to a simmer. Cook, stirring constantly, for 1 to 2 minutes or until thickened. Stir in cheese and sour cream. Stir in eggs. Pour mixture over broccoli, stirring until well blended. Arrange tomato slices on top, if desired.

Bake for 45 minutes or until center is done.

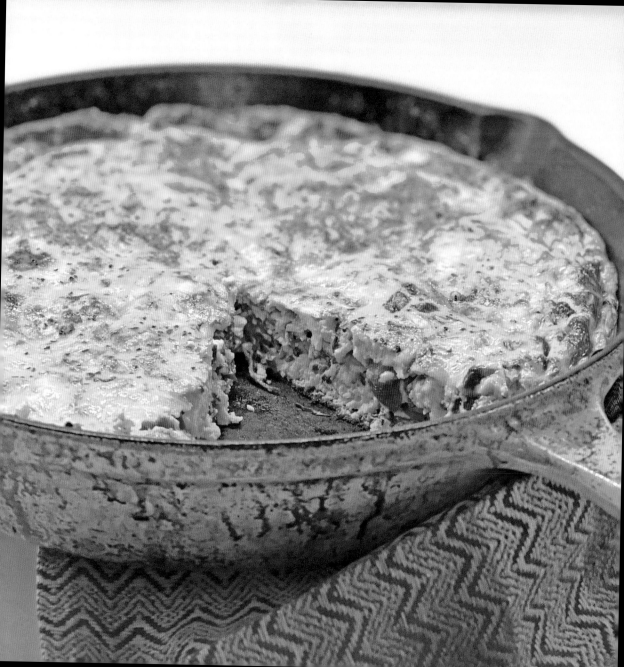

Arugula-and-Bell Pepper Frittata

Arugula is a member of the cruciferous family of vegetables, which explains its pungent, peppery flavor.
This recipe uses packaged baby arugula because it's easier to find and the small leaves wilt easily with heat.
If you use bunched mature arugula, wash it thoroughly and coarsely chop it,
so it cooks down to a tender texture. If you prefer the milder flavor of spinach, do the same.
A medium-size, well-ripened tomato makes a good substitution for the bell pepper.

makes 6 servings

INGREDIENTS

8 large eggs
½ cup half-and-half or
 whole milk
¾ teaspoon salt
½ teaspoon coarsely ground
 black pepper, divided
1 tablespoon extra-virgin
 olive oil
½ small red or yellow onion,
 chopped
1 (5-ounce) container baby
 arugula or spinach
1 roasted red bell pepper,
 chopped
½ cup (2 ounces) shredded
 Havarti or mozzarella cheese,
 divided
¼ cup (1 ounce) shredded
 Parmesan cheese, divided
Hot sauce (optional)

Whisk eggs, half-and-half, salt, and ¼ teaspoon black pepper in a bowl; set aside.

Heat oil in a 10-inch cast iron or ovenproof nonstick skillet over medium heat. Add onion and cook for 5 minutes, stirring often, or until tender.

Meanwhile, place oven rack 8 inches away from top of oven; preheat broiler.

Stir arugula into onion, tossing with tongs. Cover and cook for 2 minutes or until arugula wilts.

Pour egg mixture into skillet, folding gently to blend. Stir in bell pepper and half of cheeses. Cook for 5 minutes or until edges begin to set and bottom is cooked.

Sprinkle with remaining half of cheeses and remaining ¼ teaspoon black pepper; transfer skillet to oven. Broil 3 to 5 minutes or until cheese melts and eggs are set. Serve with hot sauce, if desired.

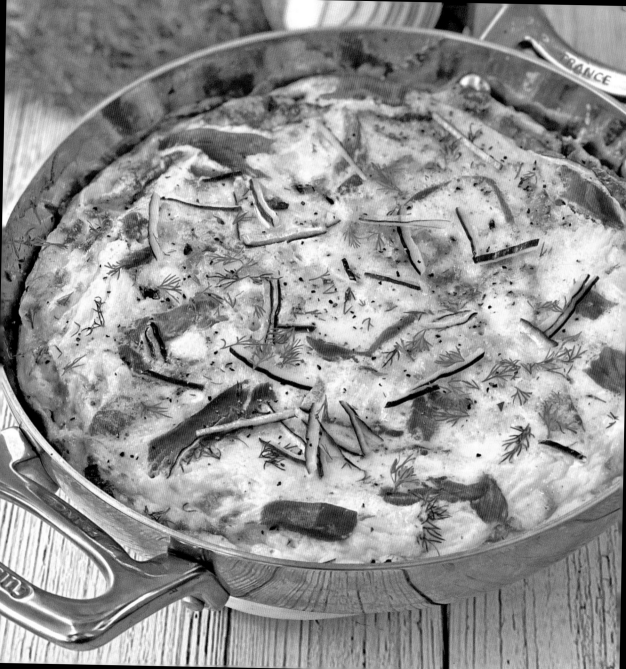

Smoked Salmon Frittata

This is one of my favorite brunch (or dinner!) dishes for many reasons,
including its amazing flavor and ease of preparation. I am an avid
sockeye salmon fan and will always recommend any of the Pacific species
of salmon. I prefer the silky texture of cold smoked salmon, but firm,
hard-smoked or even canned pink salmon is delicious in this recipe too.

makes 6 servings

INGREDIENTS

2 tablespoons extra-virgin
 olive oil
¼ cup slivered red onion
10 large eggs
½ cup sour cream or yogurt
1 teaspoon Dijon mustard
1 (4-ounce) package smoked
 sockeye salmon, cut into strips
2 ounces soft goat cheese, feta,
 or cream cheese, crumbled
1 tablespoon fresh dill leaves
½ teaspoon coarsely ground
 black pepper

Place oven rack 8 inches from top of oven; preheat broiler.

Heat olive oil in a large cast iron or ovenproof skillet over
medium-high heat. Add onion and cook, stirring occasionally,
for 3 minutes or until tender.

Whisk together eggs, sour cream, and mustard in a large
bowl. Stir in salmon and goat cheese.

Pour egg mixture into skillet with onion. Cook, without
stirring, for 5 minutes. Periodically lift edges with a spatula,
letting uncooked egg mixture flow underneath.

Transfer frittata to oven and broil for 3 minutes or until top is
set. Sprinkle with dill and pepper before serving.

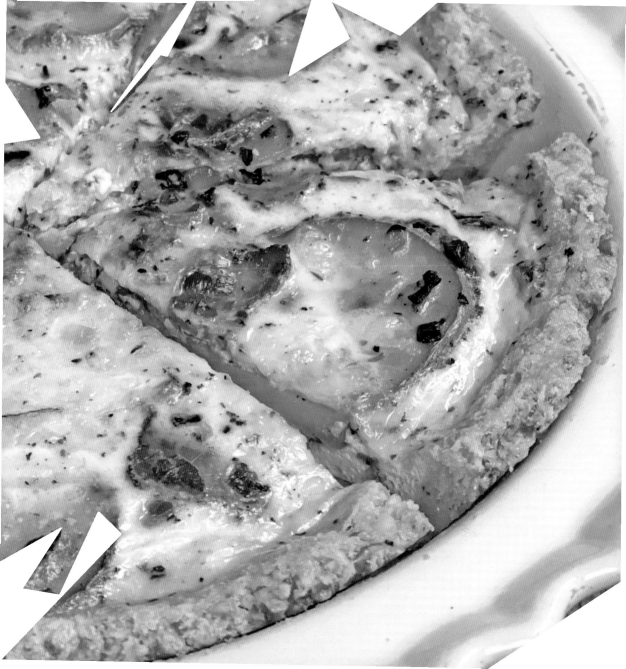

Potato-and-Bacon Quiche in a Parmesan Crust

Cheese in the pastry crust gives it extra flavor and a bit of crunch where it cooks to a golden brown. It's so easy to make in a food processor, and you can substitute gluten-free baking mix for the flour.

makes 6 servings

INGREDIENTS

Parmesan Crust (recipe at right)
1 tablespoon salted butter
2 red or 4 baby red potatoes, thinly sliced (12 ounces)
½ small onion, finely chopped
4 slices bacon, cooked and crumbled
3 large eggs
¾ cup half-and-half or milk
½ teaspoon salt
½ teaspoon dried Italian seasoning
½ teaspoon coarsely ground black pepper
¼ cup (2 ounces) shredded Manchego, Swiss, cheddar, or other cheese

Preheat oven to 350°. Prepare Parmesan Crust; fit into a 9- or 9½-inch-deep pie plate.

Melt butter in a large skillet over medium-low heat. Add potatoes and onion. Cover and cook for 10 minutes, stirring occasionally, until potatoes are just cooked. Stir in bacon and spoon into prepared crust.

Whisk together eggs, half-and-half, salt, seasoning, and pepper in a bowl. Pour egg mixture over potato mixture. Sprinkle with cheese.

Bake for 30 minutes or until golden brown and set.

Parmesan Crust: Combine **1 cup (4 ounces) shredded Parmesan, Romano, or Asiago cheese; ¾ cup all-purpose flour; ¼ teaspoon salt; and ¼ teaspoon coarsely ground black pepper** in a large bowl or food processor, stirring well. Add **4 tablespoons unsalted or salted butter, cut into pieces,** cutting in with a pastry blender or fork; pulse for several seconds in processor. Add **1 to 2 tablespoons water,** 1 tablespoon at a time, blending or pulsing until a shaggy dough forms. Press into a 9- or 9 ½-inch-deep pie plate. Makes 1 (9-inch) piecrust.

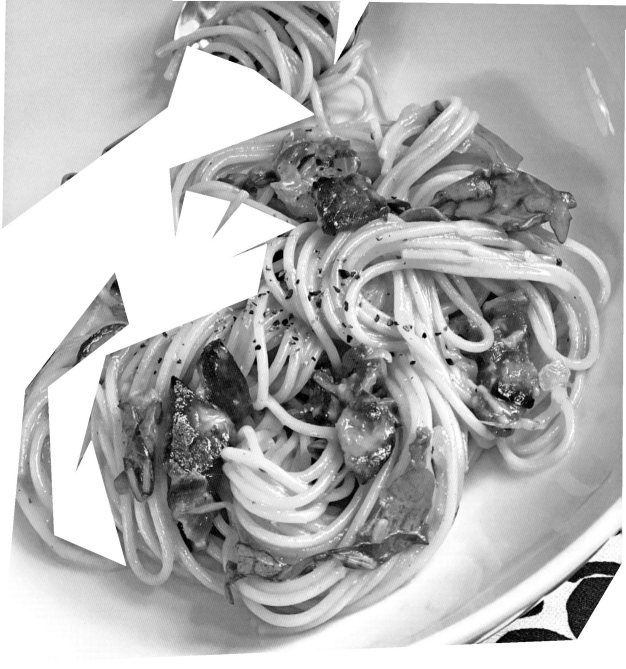

Spaghetti Carbonara with Arugula

Make sure the skillet is warm but not hot when you add the eggs or they will cook or curdle before coating the pasta. If you work quickly, the heat from the pasta will cook the egg mixture, creating a silky sauce and coating the noodles. If the sauce doesn't appear to be thickening because your skillet or ingredients are cool, heat the skillet over very low heat while stirring constantly.

makes 4 servings

INGREDIENTS

3 large eggs,
 at room temperature
½ cup (2 ounces) freshly grated
 Romano or Parmesan cheese
½ teaspoon salt
¼ teaspoon coarsely ground
 black pepper
4 slices thick lean bacon,
 chopped
½ small onion, finely chopped
2 garlic cloves, finely chopped
⅛ teaspoon crushed red pepper
 flakes (optional)
8 ounces uncooked spaghetti,
 angel hair, or other pasta
4 cups lightly packed arugula
 and/or spinach blend

Whisk together eggs, cheese, salt, and black pepper in a small bowl. Set aside.

Cook bacon in a large skillet over medium heat for 10 minutes or until almost crispy. Add onion, garlic, and, if desired, red pepper flakes. Cook for 5 minutes or until onion is tender and golden brown. Remove from heat.

Cook pasta in boiling salted water according to package directions. Drain pasta, reserving ¼ cup cooking liquid. Add pasta to skillet, stirring until well blended. Quickly add egg mixture to hot pasta mixture, tossing to coat.

Stir arugula into pasta mixture. Add reserved pasta water, a few tablespoons at a time, and cook over very low heat, stirring constantly, until sauce thickens and pasta is thoroughly heated.

Chicken, Egg, and Rice Casserole

The mild flavor of this homey casserole suits almost everyone.
I always make extra cooked rice and/or chicken and store it in the freezer for recipes
like these where not much is needed and I want to reduce prep time.
Grilled or rotisserie chicken is delicious in this recipe too.

makes 6 servings

INGREDIENTS

Vegetable cooking spray
2 tablespoons butter
1 tablespoon extra-virgin
 olive oil
1 onion, finely chopped
2 celery stalks, chopped
2 garlic cloves, minced
3 tablespoons all-purpose flour
1½ cups chicken broth
½ cup mayonnaise
¼ cup sour cream
1 tablespoon fresh lemon juice
½ teaspoon salt
6 hard-boiled eggs, chopped
2 cups chopped or shredded
 cooked chicken
1½ cups cooked long-grain rice
⅓ cup crushed cheddar cheese
 crackers, saltines, potato
 chips, or cornflakes

Preheat oven to 375°. Lightly grease an 8x8- or 9x9-inch baking dish with cooking spray.

Heat butter and oil in a large nonstick skillet over medium heat. Add onion, celery, and garlic. Cook, stirring frequently, for 5 minutes or until tender.

Whisk in flour. Cook, whisking constantly, for 1 to 1½ minutes. Stir in broth. Cook, stirring constantly, for 3 minutes or until thickened and bubbly. Stir in mayonnaise, sour cream, lemon juice, and salt.

Stir in eggs, chicken, and rice. Pour mixture into prepared baking dish. Sprinkle with crushed crackers.

Bake for 30 minutes or until hot and bubbly.

Chiles Rellenos Casserole

Cotija is a crumbly, salty cheese that adds both flavor and texture to this well-seasoned casserole. If you can't find cotija, substitute feta cheese. Poblanos are large, dark-green peppers that are generally mild in flavor. I prefer a soy-based vegetarian chorizo because many pork-based versions are greasy. If using pork chorizo, drain after cooking.

makes 6 servings

INGREDIENTS

Vegetable cooking spray
8 large poblano peppers
1 tablespoon extra-virgin olive oil
1 small onion, chopped
6 ounces soy chorizo, Mexican
 chorizo, or lean ground beef
1½ cups shredded Monterey Jack
 or cheddar cheese
1 cup crumbled cotija cheese
6 large eggs
1½ cups milk
⅓ cup all-purpose flour
1 teaspoon baking powder
½ teaspoon paprika
½ teaspoon salt
Fresh cilantro
Chopped tomatoes

Preheat oven to 450°. Line a sheet pan with aluminum foil. Lightly grease a 9x9-inch or 2-quart baking dish with cooking spray.

Place peppers on baking sheet and roast for 10 minutes, turning occasionally, until pepper skin is charred and bubbly. Reduce oven temperature to 350°. Place peppers in a bowl; cover and let stand 10 minutes. When cool, slice in half and remove skin, seeds, and stems. Set aside.

Heat oil in a large skillet over medium heat. Add onion and chorizo. Cook, stirring frequently, until onion is tender and chorizo browns.

Combine Monterey Jack and cotija cheeses in a bowl. Place half of peppers on bottom of prepared baking dish. Layer with half of chorizo mixture and one-third cheese mixture. Repeat with remaining half of peppers, remaining half of chorizo mixture, and one-third cheese mixture.

Whisk together eggs, milk, flour, baking powder, paprika, and salt in a large bowl. Pour egg mixture over casserole; sprinkle with remaining one-third cheese mixture. Bake for 45 minutes or until golden brown and set in center. Top with cilantro and tomatoes.

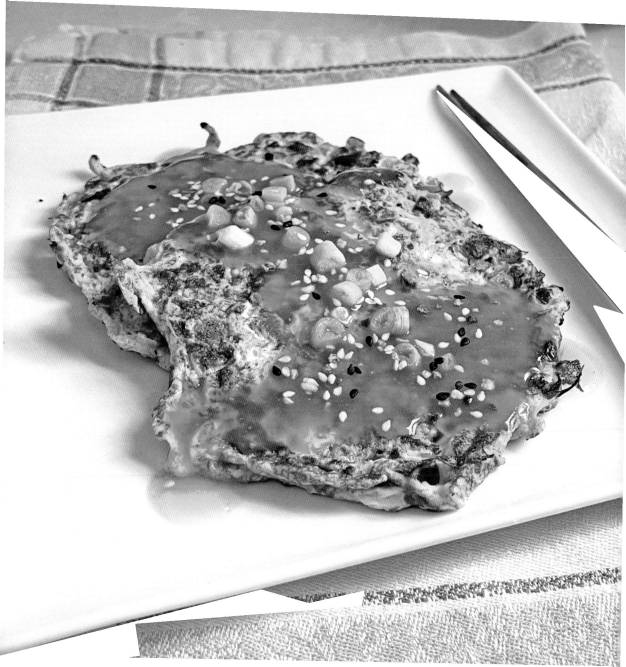

Egg Foo Young

This Chinese-inspired dish is basically a vegetable omelet that is browned a bit
more than a traditional French-style omelet. It's a great low-budget way to use up extra vegetables
because you can substitute almost any vegetable for the bell pepper, celery, and mushrooms.
Try zucchini, cauliflower, or spinach, for example!

makes 4 servings

INGREDIENTS

1 cup chicken or vegetable broth
1 tablespoon low-sodium or
 regular soy sauce
1 tablespoon rice wine vinegar
½ teaspoon toasted or dark
 sesame oil
2 tablespoons water
1 tablespoon cornstarch
1 tablespoon olive or vegetable
 oil, divided
1 teaspoon grated fresh ginger
1 garlic clove, minced
1 red bell pepper, finely chopped
1 celery stalk, finely chopped
½ (8-ounce) package baby
 bella or button mushrooms,
 finely chopped
½ small onion, finely chopped
4 green onions, finely chopped
8 eggs

GARNISH

Sesame seeds

Combine broth, soy sauce, vinegar, and sesame oil in a small saucepan over medium heat. Whisk together 2 tablespoons water and cornstarch in a small bowl. Add cornstarch mixture to broth mixture. Simmer over medium heat for 2 minutes, stirring frequently, until mixture thickens slightly. Remove from heat and keep warm.

Heat 1 tablespoon oil in a large nonstick skillet over medium-high heat. Add ginger and garlic; cook, stirring constantly, for 30 seconds. Add bell pepper, celery, mushrooms, onion, and green onions. Cook, stirring frequently, for 5 minutes or until vegetables are tender and any liquid evaporates.

Beat eggs in a large bowl. Stir in vegetable mixture.

Wipe skillet with a paper towel. Heat about ¾ teaspoon of the remaining oil in the skillet over medium-high heat. Add ¼ of the egg-and-vegetable mixture to the skillet. Cook, without stirring, for 2 minutes or until lightly browned on the bottom. Periodically lift the edge of the omelet to allow uncooked liquid to seep underneath. Flip over and cook for 1 to 2 minutes or until browned on bottom.

Transfer to a plate; cover and keep warm. Repeat with remaining oil and egg mixture. Garnish, if desired.

sweets

Crème Anglaise with Fresh Berries

This classic dessert sauce has a rich vanilla flavor that my daughter Corinne
says tastes like good melted ice cream. It has the same ingredients as a custard ice-cream
base and is delicious with fresh fruit, pound cake, or pavlovas (see page 109).

makes 1½ cups

INGREDIENTS
¾ cup whole milk
¾ cup heavy whipping cream
½ vanilla bean
4 egg yolks
¼ cup granulated sugar
Pinch of salt
Fresh berries

Place a metal or glass bowl in a larger bowl filled with ice water. Set aside.

Combine milk and cream in a medium-size heavy saucepan over medium-low heat. Split vanilla bean and scrape seeds into milk mixture. Bring mixture to a low simmer (do not boil).

Whisk together yolks, sugar, and salt. Pour ¼ cup hot milk mixture into eggs, whisking constantly. Repeat. Whisk egg mixture into milk mixture in saucepan.

Cook over medium heat, whisking constantly, for 5 minutes or until sauce thickens and coats the back of a spoon (about 170° to 180°). Remove from heat and strain into chilled metal bowl, discarding bean pod. Stir occasionally until mixture chills. Cover and refrigerate until cold.

Place fresh berries in small bowls or glasses. Drizzle with sauce.

Homemade Vanilla Bean Frozen Custard

Although the desserts look essentially the same, frozen custard differs from ice cream with the addition of egg yolks. Ice cream contains more air, making frozen custard a richer, denser treat.

makes 1½ quarts

INGREDIENTS

¾ cup granulated sugar
2 cups heavy whipping cream, divided
1 cup whole milk
¼ teaspoon salt
1 vanilla bean, split lengthwise
6 large egg yolks
Store-bought ladyfingers

Combine sugar, 1 cup cream, milk, and salt in a large heavy saucepan over medium heat. Split vanilla bean in half lengthwise and scrape seeds into mixture. Add bean pod. Cook just until sugar dissolves and mixture is warm but not boiling. Let steep for 30 minutes.

Combine remaining 1 cup cream and egg yolks, whisking until well blended. Whisk 1 cup warm vanilla mixture into yolk mixture. Add yolk mixture back into saucepan. Cook, stirring constantly, over medium heat for 5 minutes or until mixture reaches 160° and coats the back of a spoon.

Place a metal or glass bowl in a larger bowl filled with ice water. Strain custard, discarding bean pod, into chilled metal bowl. Stir occasionally until cool. Cover and refrigerate 8 hours or overnight.

Freeze custard in an ice-cream maker according to manufacturer's instructions. Transfer to a container; cover and freeze until firm. Serve with ladyfingers.

Mocha Frozen Custard: Stir **8 ounces melted bittersweet chocolate** and **1 tablespoon instant espresso powder** into hot cream mixture before adding to yolk mixture. Proceed as directed.

Dark Chocolate Pots de Crème

It is very challenging to wait until these rich cups are well chilled and firm
before dipping a spoon into the center for a taste. If dark chocolate is too intense,
substitute semisweet for a milder flavor. This version goes straight from saucepan to fridge
(others are baked in a water bath), making it more like a super-rich pudding.

makes 6 (½-cup) servings

INGREDIENTS
¾ cup whole milk
¾ cup heavy whipping cream
⅓ cup granulated sugar
Pinch of salt
4 large egg yolks
9 ounces bittersweet or semisweet
 chocolate, finely chopped
Whipped cream

GARNISH
Chocolate shavings

Combine milk, cream, sugar, and salt in a medium-size
saucepan over medium-low heat. Cook, stirring constantly,
for 3 to 5 minutes or until sugar dissolves and mixture is
hot but not boiling.

Whisk yolks in a small bowl until well blended. Slowly whisk
in ½ cup hot milk mixture. Transfer yolk mixture back to
saucepan, whisking constantly. Cook over medium heat,
whisking or stirring constantly, for 5 minutes or until slightly
thickened (mixture should measure between 160° to 170° on
an instant read thermometer). Add chocolate, stirring until
smooth and well blended.

Pour chocolate mixture into 6 (4-ounce) ramekins or small
glasses; refrigerate 8 hours or overnight. Dollop with whipped
cream and garnish, if desired.

Amaretti

This simple cookie has a bold yet enticing almond flavor that comes from the extract rather than the almond flour. The exterior is crisp, while the interior is soft and chewy.

makes 2½ dozen

INGREDIENTS
2 cups almond flour
1 cup granulated sugar
¼ teaspoon salt
½ cup powdered sugar
3 large egg whites
¾ teaspoon almond extract

Preheat oven to 325°. Line 2 baking sheets with parchment paper.

Combine almond flour, granulated sugar, and salt in a large bowl. Place powdered sugar in a wide shallow bowl.

Whisk egg whites and extract with an electric mixer until soft peaks form. Fold ¼ egg white mixture into almond flour mixture. Gently fold in remaining egg white mixture, taking care to keep the mixture as light as possible.

Form dough into 1-inch balls and roll gently in powdered sugar. Place 1½ to 2 inches apart on prepared baking sheets.

Bake for 15 to 18 minutes or until golden brown. Cool on pans for 5 minutes, and then transfer to wire racks to cool completely. Store in an airtight container.

Double Chocolate Meringue Cookies

If you enjoy dark chocolate, you'll love these flourless fudge cookies. If you prefer
a less intense treat, substitute milk chocolate chips. Either way, they are amazing with a big glass of milk.
Or you can pair them with a glass of red wine. I prefer a versatile Pinot Noir, but, in general,
you can pair dark chocolate with a hearty red and sweeter chocolate with a lighter bodied wine.

makes 2½ dozen

INGREDIENTS
Vegetable cooking spray
2 cups powdered sugar
½ cup cocoa powder
¼ teaspoon salt
3 large egg whites,
 at room temperature
2 teaspoons vanilla extract
2 cups semisweet or dark
 chocolate chips

Preheat oven to 350°. Line 2 sheet pans with nonstick
aluminum foil or parchment paper. Lightly grease parchment
or spray with cooking spray.

Combine powdered sugar, cocoa powder, and salt in a large
bowl. Whisk egg whites and vanilla in a small bowl. Stir egg
white mixture into sugar mixture. Fold in chocolate chips.

Drop batter by rounded tablespoonfuls onto prepared
baking sheets.

Bake for 15 minutes. Cool on pans on wire racks. Transfer to
an airtight container.

Individual Peach and Blueberry Pavlovas

Fluffy, light, and crunchy meringues are the base for this elegant dessert.
Make the meringues a few days ahead, if desired, and make sure they are covered in plastic wrap
or stored in an airtight container so they don't get soft. For added richness, drizzle with Crème Anglaise (page 99).

makes 8 servings

INGREDIENTS

6 egg whites
½ teaspoon cream of tartar
¼ teaspoon salt
1 teaspoon vanilla extract
1½ cups granulated sugar
1½ cups heavy whipping cream
2 tablespoons powdered sugar
⅓ cup sour cream
1 pint fresh raspberries
4 ripe peeled peaches or
 nectarines, sliced
½ cup fresh or frozen blueberries
Crème Anglaise
 (optional; see page 99)

Preheat oven to 225°. Line 2 baking sheets with nonstick aluminum foil or parchment paper.

Beat egg whites, cream of tartar, and salt at medium speed with an electric mixer until foamy. Increase speed to high and add vanilla. Add granulated sugar, a few tablespoons at a time, until stiff peaks form.

Pipe or spoon meringue into 8 (6-inch) circles, creating a slight indentation in each center. Bake for 1½ hours, rotating pans halfway through cooking time. Turn oven off, and then allow meringues to stand in oven for 1 hour. Remove and cool to room temperature.

Beat whipping cream and powdered sugar with whisk attachment at high speed with an electric mixture until soft peaks form. Whisk in sour cream. Spoon whipped cream mixture evenly in the center of each pavlova. Top evenly with fresh fruit. Drizzle with Crème Anglaise, if desired.

Tart Lemon Bars

With bar recipes like brownies, I line the baking pan with nonstick aluminum foil so
the treats are easy to lift out of the pan for cutting, with nothing sticking on the bottom.
However, with citrus recipes, I use parchment paper to avoid any metallic flavor that may transfer.
Make sure the parchment is folded at the corners with no tears or the filling may seep under the paper.
You can also use a glass baking dish and skip the parchment, though you
may lose some yield getting the edge pieces out (those are the "tasting" pieces!).

makes 1 dozen large or 3 dozen small bars

CRUST
2 cups all-purpose flour
½ cup powdered sugar
¼ cup cornstarch
½ teaspoon salt
¾ cup unsalted butter, melted
1 teaspoon vanilla extract

FILLING
8 large eggs
2 cups granulated sugar
¼ cup all-purpose flour
2 teaspoons grated lemon zest
½ teaspoon baking powder
1 cup fresh lemon juice
Powdered sugar

Preheat oven to 350°. Line a 13x9-inch baking pan with parchment paper, cutting and fitting so 2 inches extends over the sides.

To make crust, combine 2 cups flour, powdered sugar, cornstarch, and salt in a large bowl. Stir in butter and vanilla.

Pat dough into prepared pan. Bake for 17 to 20 minutes or until pale golden brown.

Meanwhile, to make filling, beat eggs, granulated sugar, and ¼ cup flour until well blended. Stir in lemon zest, baking powder, and juice.

Pour filling over warm crust. Return to oven and bake for 20 to 25 minutes or until filling is just set. Cool to room temperature in pan on a wire rack. Refrigerate several hours or until completely chilled.

Cut into squares and dust with powdered sugar before serving.

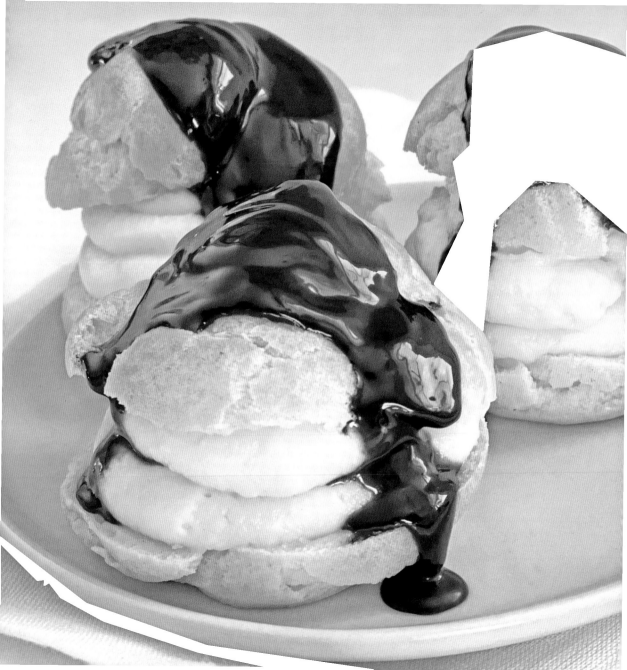

Cream Puffs with Chocolate Sauce

You can make the unfilled puffs up to 2 days ahead (or freeze up to 4 weeks), but they will become soft. To re-crisp the exterior, reheat at 300° for 10 minutes.

makes about 2 dozen

INGREDIENTS

1 cup water
½ cup (1 stick) unsalted or salted butter
¼ teaspoon salt
1 cup all-purpose flour
4 large eggs
Vanilla Pastry Cream (recipe at right), chilled
Jarred fudge sauce

Preheat oven to 375°. Line 2 baking sheets with nonstick aluminum foil or parchment paper.

Combine 1 cup water, butter, and salt in a saucepan over medium-high heat and bring to a boil. Add flour and cook 3 minutes, stirring constantly, until dough comes away from sides of pan. Transfer to a mixing bowl. Beat on low speed for 3 minutes. Beat in eggs, 1 at a time, stopping to scrape sides.

Create 12 balls of dough. Place 1½ to 2 inches apart on prepared baking sheets. Bake for 25 to 28 minutes or until golden brown. Remove from oven and pierce sides of each puff with the tip of a knife to release steam. Cool on a wire rack.

Split cream puffs in half, cutting almost all the way across. Pipe 2 to 3 tablespoons cold Vanilla Pastry Cream into each cream puff. Serve with warm chocolate sauce.

Vanilla Pastry Cream: Heat **2 cups whole milk** in a saucepan over medium heat. Bring to a simmer. Whisk **4 egg yolks** and **⅓ cup granulated sugar** in a metal bowl until pale and fluffy. Whisk in **3 tablespoons cornstarch** and **⅛ teaspoon salt**. Whisking constantly, add milk mixture slowly to egg mixture. Transfer back to saucepan. Cook over medium-high heat, whisking constantly, for 2 to 3 minutes or until thickened. Stir in **2 tablespoons unsalted butter** and **½ teaspoon vanilla**. Cover with plastic wrap. Makes 2 cups.

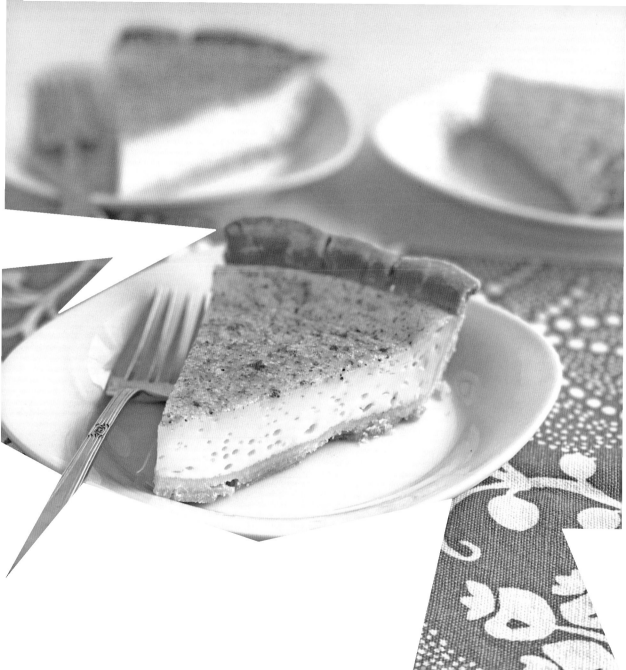

Egg Custard Pie

This pie is all comfort! To get the smooth, silky texture, be sure you don't overbake it.
Remove from the oven almost set—it will jiggle just a little in the center.
Don't worry—it'll firm up when cool. Whole milk can be substituted, though the pie will be less rich.
Brushing the egg white over the crust creates a barrier so the liquid won't soak into it and make it soggy.

makes 1 (9-inch) pie

INGREDIENTS
1 purchased refrigerated piecrust
1 large egg white
3 large eggs
1½ cups half-and-half
⅔ cup granulated sugar
⅛ teaspoon salt
¼ teaspoon ground nutmeg
1 teaspoon vanilla extract

GARNISHES
Whipped cream
Ground nutmeg

Preheat oven to 350°. Brush bottom of piecrust with egg white.

Whisk together eggs, half-and-half, sugar, salt, ¼ teaspoon nutmeg, and vanilla in a large bowl. Pour egg custard mixture into prepared crust.

Bake for 55 to 60 minutes or until edges of pie are firm and center barely jiggles. Shield edges of piecrust after 30 minutes to prevent overbrowning.

Cool on a wire rack until room temperature. Chill pie in refrigerator until cold and firm.

Garnish, if desired.

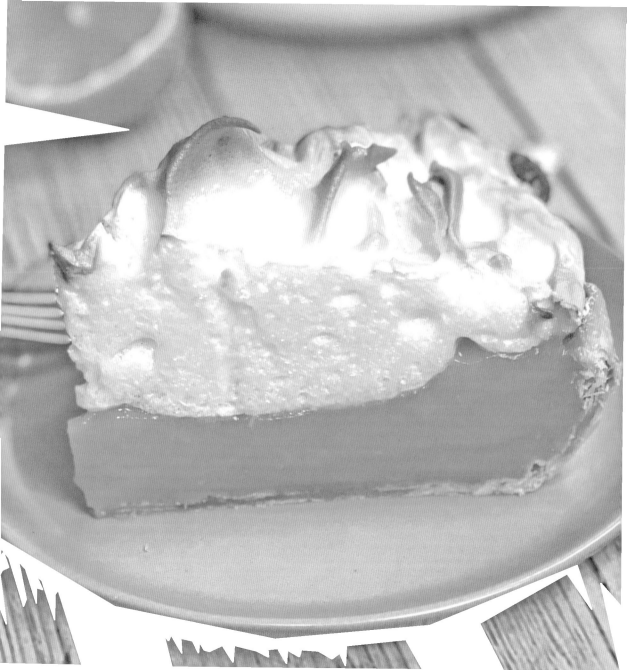

Lemon Meringue Pie

Always use fresh juice when making this pie so the lemon curd filling tastes tangy and bright.
You don't have to cover the pie during the first round of chilling, but any leftovers should be covered in the fridge.
Insert toothpicks and let plastic wrap rest on top to keep it from sticking to the meringue.

makes 1 (9-inch) pie

INGREDIENTS

1 purchased refrigerated piecrust
1½ cups water
1¼ cups granulated sugar
1 teaspoon grated lemon zest
½ cup fresh lemon juice
⅓ cup cornstarch
4 egg yolks
4 tablespoons unsalted or
 salted butter
¼ teaspoon salt
Meringue (recipe at right)

Preheat oven to 425°. Fit piecrust in a 9-inch pie plate and bake according to package directions. (If using a homemade crust, prick bottom and edges with a fork or line with aluminum foil or parchment paper and fill with baking weights or dried beans. Bake for 10 minutes. Remove foil and weights and bake 5 minutes or until golden brown.) Reduce heat to 350°.

Combine 1½ cups water, sugar, zest, lemon juice, cornstarch, and yolks in a saucepan over medium heat. Bring mixture to a boil, reduce heat, and simmer, stirring constantly, 1 minute or until mixture thickens. Add butter and salt, stirring until well blended. Spoon filling into prepared crust.

Spread Meringue over hot filling to edge of crust, covering all yellow filling completely. Bake 10 minutes or until golden brown. Cool to room temperature on a wire rack. Chill 4 to 6 hours before serving.

Meringue: Combine **4 large egg whites** and **½ teaspoon cream of tartar** in a mixing bowl. Beat at low speed until foamy. Increase speed to high and beat until soft peaks form. Gradually add **⅓ cup granulated sugar,** beating until stiff peaks form. Makes about 4 cups.

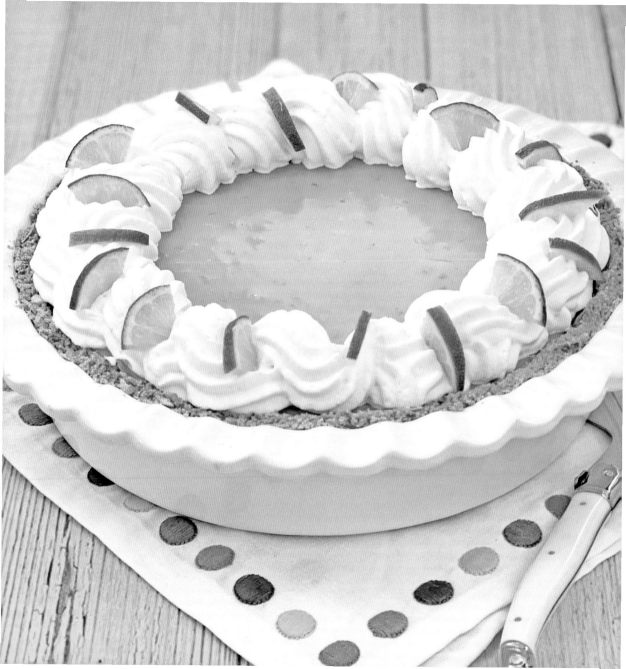

Key Lime Pie with Nut Crust

This is Florida's state pie. Its tart and sweet flavor is delicious on warm days. Key limes are not always in season or available, so feel free to use the Persian limes that are commonly found in markets. The best flavor comes from using fresh lime juice; resist using bottled. There's a lot of crust and filling; be sure to use a deep-dish pie plate that has a depth of 1½ to 2 inches.

makes 1 (9-inch) pie

INGREDIENTS

Almond-Coconut-Graham Crust
 (recipe at right)
2 teaspoons grated lime zest
1 cup fresh lime juice
2 (14-ounce) cans sweetened
 condensed milk
5 large egg yolks
Whipped cream
Lime slices

Preheat oven to 350°. Prepare crust and set aside.

Combine lime zest, juice, condensed milk, and yolks in a large bowl, stirring until well blended.

Pour filling into prepared crust. Bake for 15 to 20 minutes or until filling is almost set (center should jiggle slightly).

Cool on a wire rack for 30 minutes or until cooled to room temperature. Transfer to refrigerator and chill 8 hours or until completely cold. Serve with whipped cream and lime slices.

Almond-Coconut-Graham Crust: Combine **1½ cups graham cracker crumbs, ⅓ cup slivered almonds, ⅓ cup shredded coconut, 1 tablespoon granulated sugar,** and **⅓ cup melted butter** in a mixing bowl. Press mixture into bottom and up sides of a 9x1½-inch pie plate. Bake at 350° for 8 minutes or until lightly golden brown. Makes 1 (9-inch) piecrust.

Sunken Chocolate Tart

This flourless dessert has a very rich, bittersweet flavor that appeals to fans of dark chocolate. The light, airy batter will fall in the center when it cools, leaving a crisp ring around the outside. It's important to use a springform or other pan where the bottom separates from the sides or you may be forced to spoon the tart out of the pan instead of having clean, wedge-shaped pieces.

makes 12 servings

INGREDIENTS

10 ounces sweet dark or semi-sweet chocolate, chopped
½ cup (1 stick) unsalted butter, cut into pieces
2 tablespoons cocoa powder
2 teaspoons vanilla extract
½ teaspoon salt
6 large eggs, separated and at room temperature
¾ cup granulated sugar
Sweetened whipped cream

Preheat oven to 325°. Butter a 9-inch springform pan and dust with cocoa powder.

Combine dark chocolate and butter in a medium-size glass bowl. Microwave in 30-second intervals, stirring occasionally, until melted. Stir until well blended. Stir in 2 tablespoons cocoa powder, vanilla, and salt. Stir in egg yolks.

Place egg whites in a large mixing bowl. Beat at low speed until foamy. Increase speed to high and beat until soft peaks form. Beat in sugar, gradually, until firm peaks form.

Spoon about 1 cup egg whites into chocolate mixture to lighten. Fold lightened chocolate mixture gently into remaining egg whites, stirring until mixture is just barely combined.

Spoon batter into prepared pan and smooth top. Bake for 50 to 55 minutes or until a knife inserted in the middle comes out clean and edges pull away from pan. Transfer to a wire rack to cool completely. Cake will fall in center as it cools.

Release sides of pan from cake. Slice and serve with sweetened whipped cream.

Flan

Sometimes called crème caramel, flan is a basic custard that is topped with a silky caramel sauce when flipped upside down. Caramel sauce is deceptive—it feels like it will never turn its signature color, but don't forget about it on the stove. Once it starts turning, it only takes a few seconds before the entire mixture is golden brown.

makes 8 servings

INGREDIENTS

3 cups half-and-half
1 vanilla bean
1 1/3 cups granulated sugar, divided
3 tablespoons water
6 large eggs
1/8 teaspoon salt

Pour half-and-half into a heavy saucepan over medium-low heat. Split vanilla bean and scrape seeds and pod into half-and-half. Heat until hot but not boiling. Remove from heat and let stand 20 to 30 minutes. Strain mixture, discarding bean pod.

Preheat oven to 325°.

Combine 2/3 cup sugar and 3 tablespoons water in a heavy saucepan over medium-high heat. Cook, stirring frequently and swirling pan, until sugar dissolves. Continue to cook, without stirring, for 6 to 8 minutes or until caramel is golden brown. Occasionally brush sides of pan with water and swirl pan to distribute color. Immediately pour into a 9-inch-round cake pan. Swirl to evenly coat bottom.

Whisk eggs in a large bowl. Whisk in half-and-half mixture, remaining 2/3 cup sugar, and salt. Pour custard into cake pan. Place in a large roasting pan. Pour hot water into roasting pan until it reaches halfway up the side of the cake pan.

Bake for 50 to 55 minutes or until center is just set (center will jiggle slightly). Carefully remove from pan and cool on a wire rack for 30 minutes. Cover and chill for 8 hours or overnight.

Run a knife around edge of flan. Place a rimmed serving plate or platter upside down over the top. Invert and remove pan. Serve immediately.

Angel Food Cake

While greasing and flouring pans is critical for the success of many cakes, angel food is an exception.
The eggs need to cling to the sides of the deep cake pan to create the airy texture
and prevent the entire thing from slumping down while baking.
Use cake flour for a tender texture; however, if it's not available, you can substitute all-purpose flour.

makes 1 (10-inch) cake

INGREDIENTS
12 large egg whites
¾ teaspoon cream of tartar
¼ teaspoon salt
2 teaspoons vanilla extract
1 cup granulated sugar
1 cup cake or all-purpose flour
Fresh berries
Powdered sugar (optional)

Preheat oven to 350°.

Beat egg whites in a bowl with a mixer at high speed until foamy. Add cream of tartar and salt; beat until soft peaks form. Beat in vanilla. Add granulated sugar, a few tablespoons at a time, beating until still peaks form. Fold in flour, ¼ cup at a time.

Pour batter into an ungreased 10-inch tube pan, spreading evenly. Break air pocket by cutting through batter with a knife. Bake for 20 to 25 minutes or until top is light golden brown and cake springs back when gently pressed in center. Invert pan; cool completely.

Run a knife along the edges of the pan to loosen cake from sides. Invert onto a plate and remove base. Serve with berries or other fruit, and sprinkle with powdered sugar, if desired.

Lemon Pudding Cups

These mini soufflés puff up while cooking, and then quickly fall.
They have a rich, pudding-like custard at the bottom with a zesty lemon flavor.
Soufflés are usually eaten immediately, but these are delicious chilled.

makes 6 servings

INGREDIENTS
4 large eggs, separated
1¼ cups milk
3 tablespoons unsalted or salted
 butter, melted
1 teaspoon grated lemon zest
½ cup fresh lemon juice
¾ cup granulated sugar
⅓ cup all-purpose flour
¼ teaspoon salt
1 cup fresh or frozen blueberries
Powdered sugar

Preheat oven to 350°. Butter 6 (8-ounce) ramekins or coffee cups.

Combine egg yolks, milk, 3 tablespoons butter, zest, and juice in a large bowl. Stir in granulated sugar and flour.

Beat egg whites and salt in a mixing bowl on low speed until foamy. Increase speed to high and beat until firm peaks form. Fold ¼ egg white mixture into yolk mixture to lighten it. Fold remaining egg whites into lightened yolk mixture. Pour batter into prepared ramekins.

Place ramekins in a roasting pan or 13x9-inch baking dish. Pour water into the pan until it reaches halfway up the sides of the ramekins.

Carefully place in oven and bake for 40 to 45 minutes or until tops are set. Carefully remove ramekins from pan and cool on a wire rack. Cover and refrigerate until ready to serve. Sprinkle evenly with blueberries and powdered sugar.

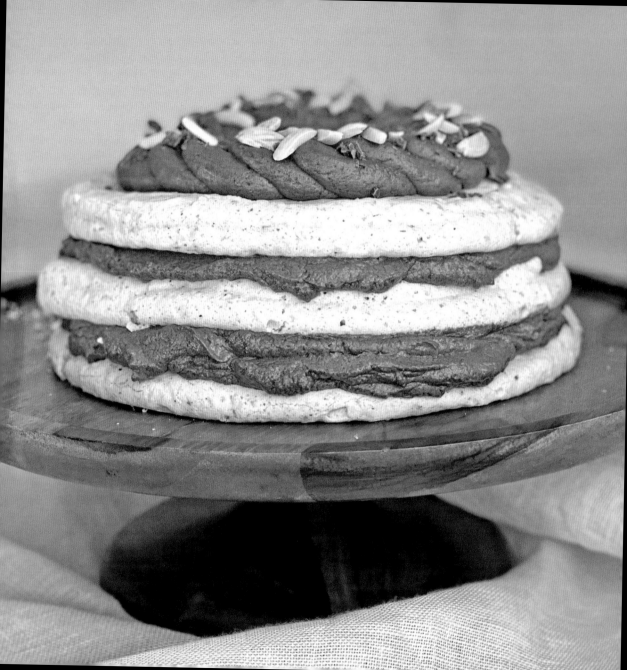

Hazelnut Meringue Cake

Use a serrated knife to slice; it's easier when the cake is cold or partially thawed, but allow it to come to room temperature before serving, as the chill blunts the flavor.

makes 8 servings

INGREDIENTS

2 cups chopped hazelnuts
1½ cups granulated sugar
6 large egg whites
¼ teaspoon cream of tartar
⅛ teaspoon salt
2 teaspoons vanilla extract
Chocolate Italian Buttercream
 (recipe on page 130)

GARNISHES

Chopped nuts
Shaved chocolate

Preheat oven to 350°. Spread hazelnuts in a single layer on a baking sheet. Toast for 4 to 5 minutes or until golden brown. If hazelnuts have skins, place in batches in a kitchen towel and rub vigorously to remove skins. Cool to 225°. Line 1 or 2 baking sheets with parchment paper and draw 3 (9-inch) circles.

Combine half of nuts and ½ cup sugar in a food processor; process for 15 to 30 seconds or until nuts and sugar are finely ground. Transfer to a bowl. Repeat with remaining nuts and ½ cup sugar. Set aside.

Beat egg whites in a mixing bowl at slow speed until foamy. Add cream of tartar and salt; increase speed to high and beat until soft peaks form. Add vanilla and remaining ½ cup sugar, beating until stiff peaks form. Fold in nut-and-sugar mixture.

Pipe or spoon meringue evenly into drawn circles, smoothing tops of each one to an even thickness. Bake for 1 hour and 15 minutes, rotating pans halfway through baking time. Turn oven off, and allow meringues to stand in oven for 1 hour. Remove from oven and cool to room temperature.

Spread one-third frosting on top of each meringue, and stack on top of each other to form a three-layer cake. Garnish, if desired.

Chocolate Italian Buttercream

· ·

makes 4 cups

INGREDIENTS

¾ cup granulated sugar
¼ cup water
4 large egg whites
¼ teaspoon cream of tartar
⅛ teaspoon salt
1 cup (2 sticks) unsalted butter, at room temperature
6 ounces bittersweet chocolate, melted
2 teaspoons vanilla extract

Combine sugar and ¼ cup water in a saucepan over medium-high heat. Cook, stirring occasionally and swirling pan, until sugar dissolves. Continue to cook, without stirring, until sugar syrup reaches 240°. Remove from heat.

While sugar syrup cooks, beat egg whites on low speed with an electric mixer until foamy. Increase speed to high and beat in cream of tartar and salt. Beat until soft peaks form. (Ideally time this so the sugar syrup and meringue are ready at the same time. Start beating the egg whites when the syrup reaches 200° to 225°.)

With mixer running, carefully pour sugar syrup in a slow, steady stream down the side of the bowl into the meringue, beating until stiff peaks form and mixture has cooled down to about 100°. With mixer running, add butter, 1 tablespoon at a time, beating until frosting is light and smooth. (If frosting breaks, it probably means the meringue was too hot for the butter. Refrigerate for 15 minutes and continue to beat until smooth.) Beat in melted chocolate and vanilla.

Index

About the Author

Julia Rutland is a Washington, D.C.-area writer and recipe developer whose work appears regularly in publications and websites such as *Southern Living, Coastal Living,* and *Weight Watchers* books. She is the author of *Discover Dinnertime, The Campfire Foodie Cookbook, On a Stick, Blueberries, Squash, Foil Pack Dinners, Apples, 101 Lasagnas & Other Layered Casseroles, Tomatoes, Honey,* and *The Christmas Movie Cookbook.* Julia lives in the Washington, D.C., wine country town of Hillsboro, Virginia, with her husband, two daughters, and many furred and feathered friends.